W9-AZD-584

The Graphic
Designer's and
Illustrator's Guide
to **Marketing
and Promotion**

The Graphic
Designer's and
Illustrator's Guide
to **Marketing
and Promotion**

Maria Piscopo

**ALLWORTH
PRESS**
NEW YORK

10 09 08 07 06 6 5 4 3 2

Published by Allworth Press
An imprint of Allworth Communications, Inc.
10 East 23rd Street, New York, NY 10010

Cover design by Derek Bacchus

Page composition/typography by SR Desktop Services, Ridge, NY

Library of Congress Cataloging-in-Publication Data
Piscopo, Maria, 1953–
 The graphic designer's & illustrator's guide to marketing
& promotion / Maria Piscopo.
 p. cm.
 Includes index.
 ISBN: 1-58115-363-5
 1. Graphic arts—Marketing. 2. Design services—
Marketing. 3. Sales promotion. I. Title: Graphic designer's
and illustrator's guide to marketing & promotion. II. Title.

NC1001.6.P577 2004
741.6'068'8—dc22 2004012589

Printed in Canada

CONTENTS

I mentioned several times while writing this book that it seemed much like trying to hit a moving target. Many things have changed in graphic design and illustration, including who does what, what it is called, and how the work is done. The good news is that these changes allowed me to finally write a "crossover book" and talk to both designers and illustrators. The better news is that you now have many more opportunities for marketing and selling your work. This book will make a difference in your life: helping you discover what it is you love to do, aiding you in finding the time to do it, and showing you how to get paid what you are really worth.

Of course, there are many changes happening as this book is being designed, produced, and printed. New technology and clients' perceived need for speed have been driving many of the changes. I will often use the term "creative professional" as a stand-in for "graphic designer and illustrator." Designers are creating illustrations, illustrators are designing, and everyone is a consultant. Maybe this is a good thing; you can make more money when you offer more services. Sorting it all out to create your personal marketing plan is the real trick.

If you are just starting out, you have the advantage of learning it all as new information and without any preconceived notions. In fact, I hope to use this book as a textbook to give students a reality check

before sending them out into the world. For those of you that have been in business for some time, you will find the "gold nuggets" in many of the case studies and anecdotes featured in this book. I have met many of these creative professionals in the work I do writing for trade publications such as *Communication Arts* and *STEP inside design* and teaching my classes at local colleges. The generosity and openness of the designers and illustrators I interviewed is amazing and, at times, brilliant. I thank them for their professionalism and patience.

In addition, working as an instructor for Dynamic Graphics Training has given me many opportunities to meet professionals ready to learn and grow together. The class, Managing Creative Services, has convinced me completely that being in business and being creative is not an oxymoron. Sherry Rodgers, you are the best there is and don't you ever forget it!

While I am on the topic of people I need to thank, I would like to thank Patrick Doyle, his son First Doyle, and the entire Doyle clan for making me feel once again like a daughter and a sister. Thanks to my adopted family: Jeff Clark, Sally Wentink, Madison Clark, Isaac, Karen, Jacob, Heather Howard, and Desiree and Matthew Pakinas. Also, I am blessed with an extended family at First Congregational Church that includes Dr. Jim Schibsted, Penelope Schibsted, John Michael and Danielle Morookian, Robbie and Marsha Robinson, and all the members of FCCA we call our family. I would like to dedicate this book to a new addition to our family, Angelina Terese Morookian, because when she smiles up at me, I can see the future.

Special thanks to Stephen Webster of the Worldwide Hideout for the outstanding book cover artwork, Tad Crawford and Nicole Potter for believing in me and for their patience and support in the process of creating this book.

I would like especially to thank management consultant John Bernat for a superior job as a contributor to the diagramming, editing, transcribing, and translating my thoughts and ideas for this book.

Finally, here is an overview of what you will find in this book. In the early chapters, you will learn to target your markets, write your marketing message, and focus on the areas you want to get work in. You will look at researching, using the Internet and traditional methods to find your prospective clients. We will discuss creating and maintaining a client contact database for managing the information from your research, portfolio presentations, and follow-up.

The key to successfully approaching prospective clients is to avoid making "cold calls," so you will learn the four steps to selling and helping clients hire you. Creating effective promotion pieces and specialty advertising promotions is a well-documented chapter. We will look at how to sort your body of work into different portfolio formats for different selling situations.

Pricing strategy is an important topic for today's creative professionals. In chapter 7, you will find negotiating techniques to make your pricing easier and more efficient. We will discuss how to present the added value of working with you and the hidden cost when the client doesn't choose you!

To make managing design and illustration projects simpler, beef up your business side. Pick up new techniques for finding more time and learn project stress management techniques in chapter 8.

Everyone can benefit from professional networking, and chapter 10 tells you how to use networks to meet people who can boost your career. Learn how an inexpensive networking campaign will increase the effectiveness of your advertising, direct mail, public relations, and selling.

Because advertising is by far the most costly promotional tool, chapter 11 will look at both the objectives and criteria for designing cost-effective advertising. Publicity is the most overlooked promotional tool and the least expensive! Find out how to get your work published and to write and submit a press release, in chapter 12. In chapter 13, on direct mail marketing, you will look at criteria for successful design and promotion for both print and e-mail marketing.

Using your Web site as advertising tool, as a portfolio, and even as a project management tool is the newest marketing medium. Chapter 14 includes lessons learned from other industry sources and success stories.

Deciding where your resources of time, attention, and budget will go is best done with an overall written plan of action to insure against "shotgun" efforts (chapter 15). These efforts are never as effective as when you've prepared each area of marketing to work in concert with all the rest. Plan the work and work the plan is the key!

Finding Your Mission and Marketing Message

I t is an oft-asked question, "Are you a specialist or a generalist?" Most creative professionals believe this is a conflict, but it is not. Today, you must be both. Clients will usually hire the specialist in order to get exactly what they need. However, designers want to do it all, and that means being a generalist.

You can be both for two reasons. One, though many clients feel hiring a specialist is the safe way, once they are comfortable and happy with you, they will ask to work with you on a greater variety of projects. Will you be ready for this? To become a generalist and provide desired multiple services to current clients, you must start out as a specialist with one focused marketing message to your prospective clients. This is why it is most important to treat current clients and prospective clients differently (more on this topic in chapter 9).

Second, if you want to be a profitable and recession-proof business, it is important to have more than one marketing message. Diversification of an investment portfolio has long been accepted as a way to minimize downside risk. It is similar in your business. You will naturally want to develop multiple profit centers (types of clients) or sources of new business in your marketing plan to have a more profitable and interesting business. Each profit center or client type is

developed out of a different direction and marketing message. Best of all, it adds variety and challenge to your work.

A WORD ABOUT BUSINESS: PURPOSE, MISSION, VISION, AND VALUES

Your clients run businesses. Whether for-profit or not-for-profit, these businesses exist to serve some strategic purpose. Universally, even not-for-profit businesses have to make money to survive.

Thus, you could say that making a profit is a universal business purpose—and you'd be right. But it would be wrong to stop there.

For many years, it's been recognized that businesses that succeed and last for decades serve a purpose beyond making money. If you want to make yourself indispensable to your current and prospective design and illustration clients, you should take a little time to figure out what your client's strategic purpose is. When you have a good handle on this sense of purpose, your likelihood of succeeding in satisfying your client's needs and building a prosperous, long-term relationship increases significantly.

To become a successful business partner with your clients, it is important to look outside your industry to gain a better understanding of business strategy. Read *Built to Last: Successful Habits of Visionary Companies,* by James C. Collins and Jerry I. Porras. It's available in paperback from HarperCollins publishers. In it, you read many stories about businesses that have lasted for generations on the strength of clarity of organizational purpose. Collins and Porras say that, whether these things are put in words or not, great and successful businesses create a sense of organizational purpose. Why does this business exist? Well, to make money, surely, but to do so by meeting some set of customer needs in a unique way.

Sometimes, this is called "mission, vision, and values." So, before you go looking for new clients, go to their Web sites and look for mission statements or an articulated vision. Read them carefully (and use them in your portfolio presentations; see chapter 4). Get to under-

stand the larger reason (besides making money) that these businesses exist. The more insight you have into your prospective clients' business purposes, the more you'll be able to make yourself indispensable to their larger purposes; you are not just selling art! Also, you will be more fulfilled in creating projects for them. The more you resonate with the business's purpose, the better the creative process.

Now, if strategic purpose is a significant factor in your clients' success, is it worth considering for your own business? As we'll see later, a key decision for you to make is to treat your work as a business. For some creative professionals, this is an easy step to take; for others, it's much more difficult. Some of you see "prostitution" in working as commercial artists, or even see success as something negative or suspicious.

One thing is sure: if, consciously or not, you decide that being big or being successful is a bad thing, you will never be either one. The key is to identify what you love to create and find the clients for this work. So from this point on, I'm going to assume that you got this book because you want to grow your creative business or expand your reach as a practicing creative professional.

If you want to succeed, an excellent first step is to clarify *your own* "mission, vision, and values." We will talk more about your marketing message in a moment, but spend a few minutes now thinking about what you want to accomplish in your work as a creative professional:

- Do I want to make a lot of money?
- What seems to make me the happiest when I work creatively?
- In the creative field, who am I most familiar with? In their business, what things do I admire the most? The least?
- Would that person be willing to allow me time to be "mentored" in setting up my own creative practice?
- From all this, where do I see my creative practice in five years? Ten years? This is perhaps the single most significant

question for entrepreneurs; Collins and Porras refer to this as "vision," and say that it should be described vividly to lend direction and purpose to your work.
• How important is balance in work/family?

Is developing a "purpose, mission, and vision" something only for mega-size businesses? Not at all. Consider this example of a "vision statement" that could come from answering the above questions.

In ten years, I will be respected as a graphic designer because of the originality of my work, my reputation for ethical conduct, and my demonstrated ability to get the assignment done, on time and within budget. I will assure clarity in my client relationships by creating mutual understanding of expectations and obligations right at the beginning. I'm entitled to be paid fairly and promptly for my work. Clients will be eager to engage me because of the value I add to the accomplishment of their strategic business goals with the contribution of my creative efforts and the unique nature of my work.

Again, determining your own business mission, vision, and values is a great exercise. In reviewing the contributions by practicing creative professionals throughout this book, look for indications of their own vision and mission. Notice their assertions of "this is who we are," "this is what our creative business stands for." All of these develop a sense of organizational identity and purpose. Sometimes it's called corporate culture. Whatever it might be labeled, there is no underestimating its power to drive you and your business to long-term success.

WRITE YOUR MARKETING MESSAGE

What is a marketing message? Creative professionals use the terms "direction" and "marketing message" interchangeably. It may also be

called "target your market," but all three terms refer to finding new clients. As we mentioned above, it is a normal and healthy business practice to target more than one market for your services.

In order to target new markets for your work, first answer this question: Do you want to do more of the same work but for better clients with bigger budgets? Or, do you want to do different types of design projects and go in an entirely new direction?

Once you have answered this most basic targeting question, then you go on to the next step. Most would next ask the question, "What do I want to do?" That is the wrong question when marketing your services. Always market for what you want, not what you do every day. If you ask the question, "What do I do?" the answer may be, for example, design or illustration, and that will be too broad a marketing message. To get a more focused marketing message, you must ask yourself the question, "What do I want to do more of?" When you answer this question, it will guide you to your new clients and target market.

Notice how this underscores the importance of visualizing your marketing message. If you have not already taken the time to develop your marketing message, start with this exercise:

- What sorts of creative work do you like the most now?
- Project yourself forward to ten years from now.
- Will you be doing a lot more of this in ten years? (For the moment, don't worry about how this will occur.)
- How will it feel to be doing this work?
- Notice how much energy flows from this simple exercise.

There's no underestimating the importance and the power of this step. It lends clarity and purpose to even the most fluid of business situations. Scott Adams, the well-known creator of the Dilbert cartoon series, credited his phenomenal success to this process. In interviews, he indicated that many years before Dilbert became the success it is now, when he was just doodling, he simply saw himself as the most published

and sought-after cartoonist in the world. Once you've placed yourself in this mind-set, intermediate obstacles seem to become manageable. And all decisions you make, and the way you use your time (chapter 8), become coherent, aligned, focused, and purposeful.

There are four ways to target markets for the creative services of your vision:

Four ways to write your marketing message.

1. **By a Particular Style of Work.** This is based on how you see the world and the way you approach creative issues. Style is based on the way you solve design or illustration problems for the clients with your own brand of indi-

vidual creativity. Style is how you see the world. It could be called your artistic vision, and it is very personal. It is not specific to any subject but crosses over many subjects and different industries. Also, the work tends to be used by high-end clients (bigger budgets) and clients in cutting edge industries such as editorial or entertainment, and even some advertising clients. It takes a very secure client to go with your personal style instead of taking the safe, conservative route! If, out of your visioning exercise, you learn that the sharing of this personal creative style is of the greatest importance overall, then choose this marketing message.

2. **By a Specific Industry.** This is based on who the client is, and it is probably the most common type of target marketing because it is so easy to identify potential clients. Standard Industry Classification (SIC) coding, either by the type of product or service the client sells, is the method used to organize information on clients by almost all resource books and research. The beauty of this marketing message is that it builds on itself. For example, once you have done work for a financial firm, you can use your experience and expertise in the industry to sell to other financial companies. Another nice benefit is that the use of your work is very diverse. Every industry has a great variety of design and illustration needs. The industry-based approach is a great way to build business volume steadily and reliably.

3. **By the Use of the Work.** This marketing message is based on what the design or illustration is used for. Perhaps you really enjoy packaging design, editorial illustration, or corporate communications design. These three are good examples of targeting that works well because it helps you clearly identify the potential clients. With this marketing

message you are not locked into any particular industry. For example, industries that use packaging design often include such diverse products as food, pharmaceutical, and beauty products. "Use of work" message often means that the client achieves the development of a consistent corporate identification as a result of the value added by your graphics or illustration. The result is brand equity for the client. When you are creating brand equity with a consistent visual style, you will become more valuable to your client and less vulnerable to competition and price-cutting.

4. **By the Subject.** Mostly used by illustrators, you can target your marketing message based on what it is that you are illustrating. Examples include food illustration, architectural illustration, and fashion illustration. In targeting the subject, you will find great diversity in the use of your work, and clients will range from advertising to editorial and everything in between. The one thing in common is the subject of the illustration.

Subject marketing messages have huge potential for developing your reach and reputation. Many successful creative professionals have therefore taken this path. The upside is that you will work with many different types of clients (industries) and on many different types of projects (use of work). Its greatest downside, though, is that you end up identified with the subject for those particular clients. You cannot and will not be all things to all prospective clients. They will need to "put you in a box" (the bad news) in order to hire you (the good news).

DON'T BE TOO SPECIALIZED

It is extremely important when developing your target markets that you set up a specific target with a broad client base to get enough work. If you target a specific marketing message too narrowly, you

Gunnar Swanson's design firm uses his logo to build his own brand equity.

won't find enough work and you won't be maximizing the potential of this profit-center approach. For example, when you target with a specific style, philosophy, or approach, your base should have a broad range of industries represented. This opens up your market segment and broadens client possibilities.

In the second area of targeting a market, by type of industry, you'll find that the broad base may be represented by the various uses of your work. You don't want to be too specialized. For example, if you had just focused on newsletters (use of work) for healthcare clients (industry), you are too narrowly focused. You would need to broaden that to working on all the different uses a healthcare firm has for design or illustration.

In the third area of target marketing, by use of the work, your base can gain diversity (and profit!) from a broad range of industries, much like the targeting by style.

For the fourth marketing message, by subject, you will want to identify every use of the work you are doing in different types of industries. For example, if you selected food illustration then you would target ad agencies with food clients, food clients directly, editorial use of food illustration, and even such publishing clients as calendars, greeting cards, and cookbooks—all for your food illustrations! As you will see, the possibilities are limitless.

FINDING YOUR MISSION AND MARKETING MESSAGE WORKSHEET

What is my creative vision?

What do I like doing best, creatively?

I want to do more _____ in the future.

Here is how I see my creative business in ten years:

I have determined a list of my business values:

I have decided that I will pursue only one of the following market messages:

❑ Style of Work
❑ Industry (e.g., pharmaceuticals)
❑ Use of Work (e.g., packaging design)
❑ Subject of Work (e.g., architecture)

Finding Clients

Finding the right company is the first step to finding new clients, regardless of which marketing message you choose. This is your "lead." Lots of leads are important because, at some point, this is a numbers game. Turning each lead into a prospect is a selling step (see chapter 4), so let's spend some time on research.

NEW BUSINESS DEVELOPMENT

Developing new business has always been a weak area in creative services firms. Once you have your marketing message in hand (see chapter 1) it will be much simpler.

Targeting the right client also will minimize the rejection in selling your work so you have a lot incentive to do the research and the work.

Whether you are just starting out or expanding your business, don't identify your new business prospects by asking the question, "What do I do as a designer or illustrator?" This will not work because the usual answer is "everything." You can't sell everything to everyone. The need for you to target a message to find new clients does not mean you will be locked into one area of creative services. It just means that you will have a place to start and be able to more easily

identify the clients you want to go after. Therefore, the question changes to "What is the work I want to do more of?" The answer to this question then is your marketing message.

RESOURCES FOR TARGETING NEW CLIENTS

Here are some of the resources for targeting new clients:

TRADE DIRECTORIES. They list the name, address, and phone number of many firms. You can call or fax *library* reference departments and they can refer you to the publishers if you want to buy the directory. You can ask questions like, "Where can I find the names of healthcare companies based in Chicago area?" and they will refer you to the correct directory. Many of these reference books are now available on CD-ROM, complete with "search" keys, so you won't have to do your own keyboarding of the names. The next chapter discusses how to launch and maintain a database of this information.

INDUSTRY TRADE SHOWS AND CONVENTIONS. These are great places to gather leads as well as to view a firm's current brochures and other literature. You can identify the schedule of conventions by reading industry magazines. The major advantage of looking for clients that exhibit at trade shows is that you know they will need design for other marketing and promotional literature! You do not need to attend the trade show if you can get a copy of the exhibitor's directory from the convention managers.

TRADE ASSOCIATIONS. Often, the membership directory you receive upon joining may be all you need as a source of new business. These associations are found in the resource book *The Encyclopedia of Associations* (*http://library.dialog.com/bluesheets/html/bl0114.html*) that lists thousands of industry groups. Whether it is travel/leisure,

toys, healthcare—no matter what—there is an association of companies in this industry that are more competitive than the non-joiners, and are therefore aggressively pursuing new business. When companies join their own trade associations and actively pursue new business, you can safely assume they need design and illustration. So they are the "better" leads.

OTHER PLACES TO LOOK FOR LEADS
The more you know about prospective clients, the better presentations you make. The better the presentation, the more likely you'll find work! Doing your homework requires the establishment of a "target market" (see above discussion), so you'll know where to start looking for new clients and new business. (You can either do this research yourself or delegate it, as this part of selling does not involve client contact.)

- *The daily newspaper business section* always has information on new products, services, expansions, and personnel changes that give you the opportunity to get your foot in the door. For example, a news item that is headlined, "ABC Food Company Launches Six New Products" can be translated into a lead for food packaging design! Get into the habit of reading the business section every day.
- *Office or industrial park directories* where your studio is located give you the names and types of tenants. These may not be the kind of clients you ultimately want to work with, but they make a great "bread and butter" client base from which to launch a self-promotion strategy. Your presentation will be based on being their "local" design firm and conveniently available for their needs and services.

- *Editorial calendars of magazines you want to work with* list the themes for each issue. This information in very valuable when approaching the publication for work. Instead of being just another designer who wants to show a portfolio, you can discuss how you can meet the magazines needs and concerns in an upcoming issue.
- *Trade shows in any industry-specific target market* are one of the best sources for new business. Not every company exhibits in its own industry trade show. However, the ones that do are always going to need more promotional materials, design, and printing services than the ones that stay home!
- *Awards annuals* are good for looking for clients that have a strong sense of style and are willing to take creative risks. These "best of the best" annual awards programs recognize firms that take chances and don't always play it "safe." You can bet that if a firm used highly creative and stylish design once, they will probably do it again. You'll hear more about this in chapter 12.
- *Annual directories available in your local library reference section* will actually provide the bulk of your database of prospective clients. Once you know what you are looking for, it is so much easier for the research librarian to point you to the directory. Many of these directories are now available on floppy disk, CD, or online from Web sites, and this makes the entire process of setting up a file much easier—no keyboard work required!

The following are some sources for researching your client lists:

Ad Agencies/Design Firms/Publications
- *Adweek*, a weekly publication, and its annual directory, Adweek Agency Directory, list ad agencies and their clients

(*www.adweek.com*). Once in the Web site, click on the
"Search Directories" link.
- *The Workbook* directory for design firms and production
companies (*www.workbook.com*). Once in the site,
go to "Directory Listings."
- *Standard Rates & Data Services* (SRDS) for editorial
leads and calendars (*www.srds.com*). Once in the site,
click on the "Support Services" link.

Fine Art
- ArtNetwork (*http://artmarketing.com*) for books on
fine art marketing and buying mailing lists

Paper Products
- *2004 Artists & Designer's Market* (*www.writersdigest.com*)

Client Direct
- *Standard Directory of Advertisers* (*www.redbooks.com*)
- *Business Journal* magazine in each city lists TOP 25
"Book of Lists" (*www.bizjournals.com*)

Internet Research
- *Target Marketing* magazine's lists
(*www.targetmarketingmag.com*)

**SO WHAT KIND OF CLIENT DO YOU
REALLY WANT TO TALK TO?**

A great book on this subject is *The Discipline of Market Leaders:
Choose Your Customers, Narrow Your Focus, Dominate Your Market*, by
Michael Treacy and Fred Wiersma. Treacy and Wiersma teach that
successful businesses often target their efforts into a narrow philos-
ophy, based on how their customers demand value.

According to Treacy and Wiersma, when your client's customers make a decision to buy something, their decision is driven by their demand for value. In a long-term study of this question, the authors found that lowest possible cost to the consumer, while a desirable attribute, was not the only way businesses successfully competed for the consumer's money. People were willing to pay more than the lowest possible price for a number of reasons: something that would last longer, something that was unique by nature, or something that represented a desired long-term solution by way of a continuing relationship with the seller.

They broke this issue into three "market discipline" categories: Product Leadership, Customer Intimacy, and Operational Excellence. Operational Excellence means companies compete by being the lowest price provider, driving all possible costs out of the "supply chain." This may or may not be your best client. But once you get away from the Operational Excellence discipline, there are alternatives.

Have you ever paid more than the "Wal-Mart price" for something? Of course. Why? Because it might have been something unique, not available at Wal-Mart. Product Leadership means that your clients can charge more than the lowest possible price because they offer innovation, state-of-the art technology, or a style not easy to duplicate.

Finally, Customer Intimacy means that your client's customer will pay more because of the investment that the company makes in the *relationship*. Customers know that they will be satisfied long after the initial sale. The company cares about the customer relationship and sees keeping them happy as the source for future success.

So, what kind of client do you really want to talk to? There are three choices: the client is most interested in Operational Excellence (price), Product Leadership (uniqueness), or Customer Intimacy (relationships). When you can identify prospective client's market dis-

cipline, you can determine how to approach and sell to them. When you know whom you are talking to, you will better understand how to make yourself irresistible and indispensable to your new clients.

NEW CLIENT DEVELOPMENT CASE STUDY

Owner and founder of Willis Advertising/Design, Inc., Bud Willis (*www.willisdesign.com*) started his business twenty years ago based on word-of-mouth and referrals. When new business stopped coming in the door, it was the wake-up call for a new approach. With marketing director Beth Parsons, Bud put together an eight-point checklist to analyze and evaluate factors for new client development:

- The firm's design strengths
- Its weaknesses
- Existing client types
- Their locations and billings
- Different types of projects these clients had
- Average profitability
- Percentage of new clients from referrals and ads
- Direction to establish for new client development

With the above information, Willis Advertising was able to identify its target market and write a positioning statement. The strategy the agency adopted started with a massive research effort to identify new clients. Then, it launched a combination direct mail and telemarketing campaign.

Bud recommends you start by identifying an industry area you are strong in, then find the right size of company (by gross sales) most profitable to work with. For the materials required for self-promotion, Bud and his staff made the best use of existing marketing pieces to keep start-up costs down. Money saved on expensive promotion

pieces was directed into hiring a staff person dedicated to marketing. Marketing assistant Monique Camacho handles both the calls and the mailings. The results? Twelve new clients in the first six months. The combination of direct mail and dedicated telemarketing immediately began generating new business leads. It took six months to turn those leads into jobs. Overall, it took twelve months to increase sales by 30 percent. The real key has been having a plan and staff devoted to new client development.

ARE YOU READY FOR A MARKETING ASSISTANT?

As competition for design assignments increases, many creative professionals feel they need to get help! A marketing assistant can help you in three important ways to build your design business: finding new clients, keeping those clients coming back, and handling all the details of the marketing plan. You're probably ready for a marketing assistant if you are too busy with work to keep up with the personal contact your clients need. You are ready for a marketing assistant if:

- You have a strong style or specialty that a marketing assistant can target to clients and sell.
- You have finally decided to consider yourself first as a business, then as a designer.
- You have lots of ideas to promote your business but lack the time and expertise to implement them.

Marketing assistants work best with people who appreciate the "profit-making" nature of their work. A marketing assistant is there to realize your goals, so you must have them set before anything can happen!

You can handle an employee if you practice good business management and have a professional attitude towards promoting your business. Established and efficient project management procedures

are important criteria before bringing someone in. You have to have a portfolio of the kind of work that you want the marketing assistant to help you get. And finally, you're ready to take this step if you have a well-defined marketing plan and budget for the promotion. That way you'll be ready to support the direction and goals that you have set for your business.

Setting up Client Databases

The days of the old shoebox and index cards are long gone. This is how we used to keep track of information on clients and prospective clients. Today, a computer database is required for the maximum effectiveness and efficiency in your search for new business. There are many different software programs, both for Mac and PC systems, available for setting up databases.

A database is a list. It could be a huge list: it could contain many pieces of information on each item (called "fields"), or many thousands of items (called "records"). Here's another way to understand what a database is: the "records" are the index cards and the "fields" the pieces of information on each card, such as company and contact names, address, phone numbers, email address, Web site, etc. You can also think of a database as a table, like in the example on the following page.

Selecting the best database for you is not as easy as a word-of-mouth referral or what's on sale this week at the local software warehouse. Many designers use the database in their existing project management programs for managing client data. Some word processors include their own database programs. Whichever way you go, you won't be able to develop your business without an organized database.

Databases

	Field 1 – Name	Field 2 – Address	Field 3 – City
Record 1			
Record 2	ABC Foods	123 Main Ave.	Anaheim
	Hobie Mushroom	34 Center St.	Middleborough

1. The client or prospect is a "row" in a table or a "record."
2. A piece of information on the client is a "field." Example: "City" is a field.
 - It's anything you want to retrieve later, such as addresses, phone numbers, or dates of client contacts.

Example of a database record.

HOW TO SET UP YOUR DATABASE

There are two basic directions that will help you shop for the software that's right for you. One, you can buy a program that has a pre-existing client profile form and fields of information, called templates. This is great if this is your first database. You can simply input the client profile information from your index cards into the provided fields. It is less time in the initial set-up, but generally less flexible.

Two, you can buy a program that requires you to design the client profile form (also called "record") in a network-ready, relational database such as FileMaker Pro, and specify all of the fields and layout for each of the forms. (If you find this confusing, talk to someone at your local software store!) More time getting started, but it will be exactly what you want. Now that the newer versions of this software come with the templates for the forms and reports, it makes the set up simpler.

Client Profile Record Form

Either way, with any typical database form, your client profile will look something like the following example. A colon following a word

creates a "field" and allows that information to be searched for and retrieved at a later time.

- Alpha: (allows alphabetical retrieval for firm names like John Smith & Company; in this space, you would type "Smith")
- Firm:
- Address:
- City:
- Province or State:
- Postal code:
- Contact:
- First name:

All of the fields above can be used for printing mailing labels or merged with a word processing program for personal letters.

Check with your postal service and make sure you know exactly the requirements for addressing. In some countries, the last line of a mailing label must be the postal code or zip code, not the name of your contact!

The following fields are also necessary for contacting, and for keeping track of, contacts made:

- Addl: (usually additional contact name, such as a secretary)
- Phone:
- Fax:
- E-mail:
- Web site:
- Date last: (date of last contact)
- Type: (type of contact—phone call? appointment?)
- Date next: (date for next contact)
- Client type (this depends on your target approach and will be discussed in the next chapter)

Below are some suggested optional fields, but very useful for managing the information in your database:

- Type client: (manufacturer? ad agency? magazine?)
- Product: (usually a code, such as "m" for medical clients)
- Project name: (for follow-up and estimating purposes)
- Remarks: (where prospective client came from, or any other comments)
- Status: (usually a code to distinguish current vs. prospective clients)

Designing the form for the above "client profile" is critically important for future follow-up. Selling your design services can be as simple as managing the information on what clients and prospective clients need and when they need it! For example, the above profile allows the following scenarios: You can call prospective clients, sorted by postal code, so when you make appointments you're not driving from one end of town to the other. You can call all current clients you talked to in January that said to call back in March. You can mail new promo pieces to all prospective clients that you saw last month for your corporate identity portfolio or medical illustration portfolio. You can e-mail or mail separate and different promo pieces to magazines and corporations. All from one form!

GATHERING DATA

Now that you know what a database is, what is the quickest and most effective way to build it into something you can use?

Use Public Sources

The first source for getting information into your database is getting information from the sources described in chapter 2: Internet research, traditional newspaper and library research, and, today, buying or renting prospect information databases from third-party sources.

Use Your Registration Form

A very important second source is the "registration form" on your Web site. A registration form consists of the boxes, panels, and blanks that you ask a visitor to fill out. (Web sites will be discussed in detail in chapter 14.) Make it as easy as possible for the prospective client to provide you with the information you need. Among other things, this means following the "KISS" principle: Keep It Simple, Stupid.

Have you ever gone onto a Web site and been asked to register? In the process, what sort of thoughts have you had?

- "Do I really have time to do all this? They're asking for fifty-five pieces of information; I type fifteen words per minute. I think I'll just skip it. . . ."
- "Why do they need to know my mother's maiden name? Does this mean they are going to steal my identity?"
- "They want to know how much money I make. Is that really something I want to share?"
- "Well, instead of leaving a blank to fill in my annual income, there are 'bands' of income categories. I guess that's not so bad."
- "How do I know I won't get 'spammed' or get endless phone solicitations by leaving this information here?"

If you have felt this way, wouldn't your site visitors have the same feelings?

The first concern is time. So, try to keep your registration form as short as you can manage. How can you do that and still get the information you need? My suggestion is to keep the registration form short, and then plan for a follow up form to fill in your database. Just use the most basic elements to allow your potential clients to leave only essential demographic information on their first pass: Their name, firm name, address, e-mail, and phone numbers. Follow this up with no more than two to three quick statements indicating the nature of their interest, such as:

Check as many as apply. I visited this site because:

❏ I am now planning a project requiring graphic design or illustration within the next three months.
❏ I will be planning a project requiring graphic design or illustration within three to six months.
❏ I will be planning a project requiring graphic design or illustration and need your mini-portfolio to keep on file.
❏ I thought your work was great and want to learn more about your future projects.
❏ Other (please fill in): _____

The second concern is identity. Since most of you are doing "B2B" ("Business to Business") marketing, worry about individual identity theft is not a significant concern. However, follow this principle: never ask for something you don't need. Keep the information asked for to only those things you know you will use for your database. What "identity" elements are really crucial to building a good database? Probably not much that isn't already public information.

The third concern is privacy. If you ask for items such as "dollar volume of graphic design or illustration purchased last year," make sure you give your registrant an "out." Say at the beginning or end of your registration form that you are not requiring every field to be filled out: they are welcome to skip any field they want, for any reason. Does this mean you'll have "holes" in your database? Yes, it does. But if it makes the difference between a potentially viable contact and none at all, let the holes happen. You can easily fill them in by later communications with the potential clients. Plan to follow up any registration, no matter how complete or incomplete, with an e-mail confirmation describing additional services, and inviting additional detailed information. This confirmation should say that the receiver can opt out of any further contact if no longer interested.

The fourth concern: it's easier for client registrants to check a box or pull down a menu of choices than type in a number or words. If at

all possible, create check boxes or menus on a registration form. Make it as easy to register as you can by eliminating "fill in the blank" questions. Another benefit of this approach: you can query your database and search its contents much more easily with category information, versus "freetext" supplied by the client.

CLIENT REGISTRATION FORMS AND "SPAM"

Then there's "spam." Of course, spam is the torrent of unwanted e-mail that we get every day. It's the electronic equivalent of paper junk mail. (By the way, does it seem like we're getting less paper junk mail than we used to? Maybe there is a benefit to "spam" after all.)

No one wants a client registration form to be a source of spam. In fact, at the time of this writing, there are laws being proposed to control spam. The simplest way for a Web designer to reduce fear of spam is make a clear, explicit statement that you are committed to privacy, that you do not intend to "rent your data" to anyone else, and that if a registrant wants to be removed from your contact database, he or she need only to ask and you will do so. Clarify that a single request to remove a person from your database will be respected, and that a removal request will be total: no further contact will occur from you or your company.

If you do intend to "rent the data" or share contact information from your registration form, it is ethically imperative that you clearly advise your registrants at time of registration.

"Bounced" e-mail means e-mails you send to an address that is no longer valid. Your Internet Service Provider (ISP) may become very concerned if you have a high volume of repeated bounced e-mails. So, as soon as you receive a bounced e-mail, correct your database immediately. If you do not, your ISP may stop delivery of your legitimate e-mails.

It's possible that one of your registrants may lodge a formal "spam" complaint against you. If this happens, here's what you should do:

1. Respond immediately to the complainer.
2. Say that you are investigating the complaint.
3. If the investigation shows that the complainer had requested your e-mail, provide the documentation of that within twenty-four hours of the complaint.
4. Be specific in this response. Tell the complainer date, time, and exact terms of their request for your communication.
5. Of course, assure the complainer that you will not contact them in any form from this moment on.
6. Keep copies of this correspondence. Your ISP may want to see it.

ACTIVE VERSUS INACTIVE CLIENT RECORDS

Either due to a request not to continue contact or your own evalua-tion, you will want to provide a way to make a client record "inac-tive." Databases become less useful unless they are "pruned back" every so often. Old records could be discarded, of course, but you might want to keep them instead. They could be used for an analysis of industry trends or behavioral modeling. To do this, make sure that your database contains a field indicated whether the record is "active" or "inactive."

COMPANIES THAT DEVELOP DATABASES

There are a host of companies out there that can help you develop your database (contact management software). Some examples of these companies are:

Donnelley Marketing, *www.dataflux.com/partners/donnelley.asp*
Harte-Hanks, *www.harte-hanks.com*
Knowledgebase Marketing, *www.kbm1.com*

Other firms can provide tools that include project management databases:

ArtScope, *www.ArtScope.net*
Clients & Profits, *www.clientsandprofits.com*
DesignSoft, *www.designsoft.com*
Creo, *www.creo.com*
Intuit, *www.intuit.com*
Rebus, *www.rebus-software.com*
TimeFox by FunctionFox Systems Inc., *www.functionfox.com*

Sales Strategy

Once you have the basic information on the types of clients you want to work with (chapter 2) and it is organized into a client database (chapter 3), the next step is to start your selling strategy. Another option is to turn this work over to a representative, or rep, who will sell your work for you (see end of this chapter for case studies about working with reps).

HELP ME HELP YOU!

The key to being successful is to change your attitude and approach to selling. Don't think of it anymore as selling. Think of it as helping clients hire you. After all, you are a designer or illustrator with the kind of work they need (you did your research in chapter 2), and they are a client that needs to hire. This allows you the presumption that you are supposed to be there! In addition, clients hate buying as much as you hate selling. I have often heard clients call the process of interviewing creative professionals a "necessary evil"! It is necessary because they need you but feels "evil" because it can be so uncomfortable for them. Helping clients hire you is an attitude change everyone will benefit from.

Open-ended Selling

A good sales strategy for a creative professional must start with using the proper language of business. Most creative people approaching

the process begin their queries with phrases such as "Can you?" "Could you?" or "Would you?" These close-ended questions not only beg the client to say "No" and lead to dead-end situations, but also make you sound childlike. In other words, you need to learn the business language to ask the right questions and sound like an adult! This language is called open-ended selling, or questioning. When you begin your queries with the words "who," "what," "when," "where," "how," or "why," not only will you avoid outright rejection, but you will have a much better chance of getting that precious commodity of selling—information. The process of helping the prospect hire you is all about your ability to get relevant information. We receive information by asking the right questions and listening very carefully to the answers.

The best way to approach this is to write a "script" for the phone work you are about to launch. Scripts are simply preparation for an interaction with a client or potential client for which you have set a specific objective and must accomplish it with confidence and efficiency.

Questions Count

- **Close-Ended**
 - Do you like bright color?
 - Can you see me next Monday?
 - Would you work with a new designer like me?

- **Open-Ended**
 - What color style do you like?
 - When can we get together?
 - Where have you gotten your design work done?
 - Who does your design work now?

Examples of close-ended and open-ended questions.

STEPS TO SELLING

Now that you sound like a businessperson, here are four steps to helping clients hire you, to be successful, and avoid rejection. Note: each step has a particular goal set so low that you cannot fail!

1. **Qualify.** Get the name of the person in charge of hiring.
2. **Approach.** Schedule a presentation of your work, or get more information about the client.
3. **Present.** Get a follow-up established to build your relationship.
4 **Follow-up.** Get work.

Selling

1. Change your attitude
 - It's NOT selling
 - It's helping clients, and
 - Helping them to hire you
2. Steps
 1. Quality → who hires?
 2. Approach → how to see them?
 3. Present → how to show?
 4. Follow Up → build a relationship

There are four steps to selling.

QUALIFY: WHO HIRES?

In the first step, the goal is to identify the real client. If you are not already sure, you need to find the name of the individual with the responsibility and authority to hire you, or the name of the individual that purchases design and illustration services. Here's a typical script:

"Hello, this is (your name) from (your firm), and I'm updating the information we have on your company. Who is the person in charge of buying illustration for your marketing and promotion?" This allows you to get the name, which is all you need to do at this step! You can also write this script using the person's job title, if you know the title of the person that works with design and illustration. For example, "Hello, this is (your name) from (your firm), and I'm updating the information we have on your company. Who is the director of corporate communications?" This is a great step to delegate, since it is really just an extension of the research you have been doing.

APPROACH: GETTING THE APPOINTMENT OR INFORMATION

Because you have done your homework and matched yourself and your marketing message with the client that needs the work you want to do, you can take this "presumption" approach to getting an appointment to present your portfolio. You can presume that, if properly scripted, the prospective client will decide whether to meet with you based on his or her need for your services at the time of this phone call—timing is everything. Either way, you must walk away from this step with an agreement to view your work or, at least, information on the client's design or illustration needs.

An example script: "Hello, this is (your name) from (your firm), and I'm calling regarding your need for Web site illustration and design services. When would be a good time for us to meet?" This typical script prompts the prospective client to decide:

1. "Now." There is a need and they will meet with you or view your work.
2. "No, not now." There is no immediate need and they don't need to meet with you.

When you approach a client this way, they can make an informed choice! If they decide not to meet with you, your script should then

ask, "When should I check back with you?" If they do not want to meet with you now, then "when?" is the appropriate response for you to make. Some script options when the client says "No, not now" include:

1. When should I call back?
2. Who else looks at (name the type) portfolios?
3. What kind of ongoing need do you have for (name the type of work)?
4. How often do you use (name the type of work)?

PRESENT: YOUR WORK

The problem with the use of the term "portfolio presentation" is that it implies a one-way flow of information. To simply present yourself and your work will not give you enough information for the follow up and will probably be a waste of your energy and your client's time. The better approach is a "client consultation" to discuss their needs and your ability to meet those needs.

Since this makes each appointment with a prospective client completely unique, you can't script exactly what you will say, but you can prepare in advance of your meeting. Here is a checklist for a "client consultation" with some sample scripts.

Prepare an Introduction

Even though you may have made this appointment the day before, the person interviewing you has had many distractions since your call. While you are settling in for your meeting, review how you arrived at the client's door. Was it a referral, or a listing in a directory, or an item in the newspaper? State what you will be covering in your meeting as a "reality check" for the prospective client. This is the client's opportunity to let you know of any changes in her needs and to this meeting's agenda.

Here is a sample script: "As we discussed yesterday, I saw your firm's product line expansion mentioned in the local paper. We will look over samples from my portfolio that relate to your new products."

Go Behind the Scenes

When you are presenting work from your portfolio, be sure to discuss the "who, how, and why" and not the "what" they are looking at. Your client can clearly see *what* you are presenting, whether it is an annual report, packaging, or a Web site design. It is the creative process and problem solving that went into the work they need to hear about. Discuss whom you did the work for, how you solved the client's problem, and why you chose that solution. Design and illustration clients are hiring you for what you can do for them, not for what may look good in your portfolio. This presentation style has long been called "case study" presentations, and now, more than ever, they are important to clients. As one client so succinctly told me when discussing why she continues to work with us, she said, "Because you are the aspirin, not the headache, in my day." Our purpose is to provide solutions. Here are some examples of case study scripts:

"In this example of a newsletter design, our challenge was to come up with a two-color look on a one-color budget."

"This annual report project almost stopped when the CEO was suddenly hospitalized and we had to bring in a new client contact to work with. Since our policy is to always keep a record of our client meetings, she was able to step in without getting behind schedule."

"For this packaging project, our industry experience helped the new product manager get the job done in time for the client's annual sales meeting in New York."

"Looking at this Web site design project, we knew we needed more information on how customers were going to use the site."

Ask for a Referral

As long as you are there, have made a successful presentation, and have consulted your prospect on his or her upcoming needs, the next to last step is to ask for a referral. Don't ask closed (yes/no) questions. Be sure to ask an "open-ended" question. For example, "Do you know anyone else that should see my portfolio?" is not good and does not allow the client to take the time to think about your question. A much

better approach would be to ask, "Who do you know that should see my portfolio?"

FOLLOW-UP: THAT GETS THE WORK

Probably the biggest mistake designers and illustrators make when presenting a portfolio is not connecting this viewing, meeting, or "consultation" with the final selling step of follow-up. The follow-up to your portfolio presentation begins during the presentation and you are always the one to "ask the question." If you leave the client after viewing your work without a follow-up decided on, then you don't have one and you cannot make one up after the fact!

The key to following up and being persistent, but not a pest, is coming to this agreement or conclusion. It is literally a determination of "what happens next." There are three kinds of follow-up that you and your client can discuss and agree on to make this step happen and for you to stay in charge:

1. **When will you meet again?** Usually this is when your consultation has stimulated the prospect of a job. Sample scripts to make another appointment include: "When should we get together again?" or "When would you like to see an updated portfolio?"
2. **When will you call the client regarding a specific project or need?** In this case, there is a strong interest in future projects together but no immediate need. You can ask, "When should I call you?" or "When should I call back on that upcoming project?"
3. **When will you mail out updated promotion material as it becomes available?** Usually this is the lowest level of follow-up, as their interest or need for your services is not as strong as in the first two examples. Sample script for sending updated samples of your work: "How do you want to keep in touch?" or "When should I send more information?"

To all of the above three options you must add a timeframe, so that you can update your client contact database for both "type contact" and "date next contact." Follow-up always has a "what" is it and a "when" is it attached, and you are always in charge of it! In this way, there is always a next contact, and this strategy for portfolio presentations eliminates rejection completely because you are in charge of getting back with the client. All you need to be sure to do is ask, "What happens next?"

Ultimately, new clients come from follow-up and not the more passive presentation of your work and then waiting for the phone to ring. Do your homework, show your portfolio to clients that have the work you want to do, and then follow-up to get the jobs!

WORKING WITH A REP

A key decision for every creative professional is whether to work with a rep. Experienced and successful reps provide their own answers below. Note that the key themes are:

1. Creative professionals tend to engage reps to grow their professional reach and their income. Reps mean access to a broad market of clients.
2. A rep's "mission" is to maximize a creative professional's success and career fulfillment; one rep describes the role as "moral support," another as a "coach." The relationship is clearly collaborative.
3. The creative professional has to be comfortable trading the rep's legitimate services fees for a more rewarding creative practice (as well as significant economic gains).
4. A good rep provides sound advice about the professional's target marketing message.
5. Reps will be objective about creative output, advising you honestly of a good match with a client.
6. The rep brings both database content and expertise to the relationship. Access to a highly competitive market is the centerpiece of a rep's value.

7. Reps will help with contract negotiation (chapter 7), maximizing income, and protecting intellectual property rights. That alone could pay the rep's fees many times over.

8. Reps provide these diverse services from a single, time-efficient source, leaving you free to do what you do and like best.

Reflections from Experienced Reps

Read what successful and established reps have to say about their work. Artist's rep Gerald Rapp, of Rapp, Gerald & Cullen, Inc. (*www.rappart.com*), reflects sixty years of experience in what works (and what does not) in the designer/illustrator's relationship with a rep:

What is the job of a rep? A representative's role really has not changed very much in the sixty years we have been in business. I see our job as that of partnering with each of the illustrators we represent to maximize his or her success and the fulfillment he or she receives from their careers. Of course, each illustrator is different and has his or her own strengths and weaknesses; accordingly, the role we play in our relationships varies significantly from one illustrator to another.

Basically we offer some degree of career guidance for those of our illustrators that require it. Our other functions include marketing, selling, negotiating, billing, and collecting. Any significant decisions are always made jointly with our talent, and in the rare cases where we do not see eye to eye, our illustrators have the final word.

We have a very dedicated staff of nine, an outstanding proprietary database of over 10,000 buyers, and a state-of-the-art equipped office. For most of our illustrators, we assume responsibility for maintaining, updating, and circulating two to four traditional portfolios. Additionally, we generally assume 50 percent of all advertising and promotion expenses.

Competing optimally in today's high-tech, multinational environment requires a substantial investment, and I believe that a

well-staffed, financially strong rep firm is in a much better position to accomplish this than an individual illustrator. The current marketing mix for our firm involves trade magazine and some limited directory advertising, a strong presence on the Internet, an intelligent use of e-mail promotion, and a relentless direct mail program. The latter amounts to about half a million pieces mailed per year, including nearly 10,000 of our 100-page plus bound group portfolios, each sent with a t-shirt of the recipient's choice. This is all integrated with some traditional personal selling. And, of course, we are constantly looking for new markets for our illustrators' work.

Although most illustrators choose representation primarily to attain more and better assignments with bigger budgets, I feel that our work in negotiating sound contracts is also important. Negotiating the specifics of assignments has become far more complex than in the old days when it was mostly about money and schedule. Today we find ourselves dealing with complex contracts that frequently change without notice from one project to the next. Our role has gone well beyond just obtaining top assignments with healthy budgets: we must also protect our talent's intellectual property and obtain the best possible contractual terms for them on every job we handle.

Artist's rep Martha Spelman, of Martha Productions Inc. (also RetroReps, Artinforms, and *www.marthaproductions.com*), reflects the importance of the rep as source of encouragement and support:

> What can a representative in today's marketplace offer a creative professional?
>
> In this market—moral support! I've been repping for over twenty-three years and have seen several economic swings. It's important that a rep continues to encourage artists. As the artist's "partner" in the business, the rep can use his or her exposure to different industries to gain an overall view of the economy—what's selling, what's hot, trends, etc., and pass that information along to the artist. In addition to handling the usual business side of illus-

tration, the rep should advise on advertising and marketing including the exploration of new or untapped markets. While most artists lead more solitary working lives, reps may come in contact with more clients, other artists, other reps, etc., and have conversations that may offer insight in to the economy and the direction that the advertising, editorial, publishing, or design markets may be moving.

To a client, working with a rep group offers "one-stop shopping." Clients frequently prefer to work with one rep who can provide portfolios and information on multiple artists versus them having to contact many individual artists. A strong group of artists is a team effort—the artists should all benefit from having a strong "coach," and likewise the "coach," or rep, benefits from great players. Being part of a rep group may also lead to work with clients who may have more than one project to give out and who prefer to work with one rep.

Reps can also group their artists into a particular "genre," i.e., photographers who specialize in food or cars, or illustrators who are entertainment-oriented or book publishing specialists, or, as in the case with RetroReps, work in vintage styles. Being part of that team can assure more calls from a client in need of a specialty than may happen if an artist with that specialty is on her own or part of a more diverse group.

Leslie Burns, of artist reps Burns Auto Parts (*www. burnsautoparts.com*), says that some reps also produce for their creative professionals:

I think the most important thing I personally give to my [talent] is the freedom to concentrate on the most important aspect of their profession: the creative work itself. However, I am somewhat different because I not only rep my guys, I also usually act as their producer (however, it should be noted that I bill out separately for producing).

Regardless, even if a rep doesn't also produce, he or she still frees up the creative professional (in my case photographers) from

a lot of the work that can get in the way of concentrating on the creative aspects of any project. We build client lists, make connections, get the books out to the right people, do marketing plans, and send promos, do ads—and all the other usual things. We also deal with all the negotiations with the clients (usage and fees, etc.) and often even do at least the basic scheduling. Many of us also do the full estimating and invoicing, and the ever-popular collections. We also follow-up to make sure everything went well and that everyone connected with the project is happy with the results.

For me, at least, knowing that my talent can give their best attention to producing the best creative they can is the most important aspect of my work. I find they are more relaxed and focused, even on huge projects, and that the resulting work reflects this. When a client tells me that it was a pleasure working with us, I know I've done my job and that the client will be coming back to us for future projects.

In today's marketplace, you can't afford to make mistakes. Things are tight all over and when a client spends money on a project, you'd better give him your best each and every time. I think a rep helps a creative professional do this. If a creative professional doesn't feel like he or she is getting this from his or her rep, he or she should think about finding someone else. No matter how many promos you send, no matter how great your book is, if you can't give your best on a project the client will always notice and you will not get repeat business; and in today's tight market that could very well be your professional death.

Kolea Baker, of Artist's Representative, Inc. (*www.kolea.com*), relates the "navigation" a rep can provide. In his or her capacity, a rep "sees to the horizon" and can provide you with the benefit of that vision:

A keen sense of awareness is a must today. It is difficult for artists to look at their own work objectively or neutrally. A rep who understands art and how it is used within various markets can provide her artists with valuable suggestions. As a rep, I am much

more than a business partner. I am a forward-thinking communication partner. I provide insight for development of imagery, cultivation of emerging markets, a reality check on the competition, all of which is valuable. I believe it is part of my job to share the many facets of the business with the artists I work with. Those willing to listen and act on ideas are those that become successful. Not that an artist must take my every word and act upon it, moreover, it is the exploration of these things and what we decide to do with them that count. Better understanding translates to stronger commitment to the goal.

Also, with companies downsizing, the foothold of technology, stock, and an overabundance of artists vying for the same work, the creative art industry is traveling a bumpy path. Generally, as a reflection of these challenges, independent artists are undercutting the standard pricing structures. Large rep groups continue adding artists to their already "too large" groups. Both scenarios are reactionary and neither a good idea.

A good rep in tough times is key. Artists are inherently isolated from the market and their particular positioning in it. Some have translated this to mean that artists should unite and do all. Connection with peers and belonging to a strong established organization like the Graphic Artists Guild is important. There are dangers in artists handling their creative AND their business without a rep. For many artists, doing so can mean professional suicide. Naturally, artists are emotional about their work, making it much more difficult for them to be diplomatic and professional when selling, pricing, or problem solving their own work. As we watch the trend shift further away from illustration, it is ever more valuable to work with a leader to motivate and fight for creator rights.

Most art buyers, designers, and art directors prefer working with a good rep for obvious reasons. Focused dedication, knowledge of the industry, strong organization, clear and personable communication skills are skills that a small rep firm offers can be valuable. The fact is most artists are simply not good business people. Success and productivity arrive in the same way they

always have, it just takes more work. A full service rep like myself is essential for smoothing the path (handling business, PR, and marketing details) for the artist and client; that way each can dig and do what he does best—create.

For a great perspective on a rep's value, one of Kolea's creative professionals, artist George Abe, of Abe, Inc. (*www.georgeabe.com*), shared these thoughts on how Kolea helped him grow. Note how the quality of the collaborative relationship rests on considerable mutual understanding, respect, and trust:

> After an artist is established and has gone through the learning portion of the business (interviews, portfolio presentations, contract negotiations, and promotions) there may be a need for a rep. Kolea Baker and I have been business partners for over fifteen years. My need for a rep began when I realized that I needed more time for creating and painting. Concentrating on my strengths (art and the creative process) became too valuable of a commodity. I was wasting energy and time dealing with the business side. Not only was it a difficult part to deal with (negotiating, creating promo ideas, portfolio interviews) but I was terrible at it. Kolea has a great business sense—she knows the market, people (art directors and designers), prices, negotiating contracts, collecting, and she is creative. Having a rep is like a marriage, you have to know each other and know each other's likes or dislikes. Kolea knows what type of work I prefer, what deadlines I like/don't like, what the asking prices are for my work and who I enjoy working for (at times personality outweighs prices).
>
> When people ask me if they should look into a rep, I reply by asking them "Would you be willing to give 25 percent to 30 percent of your income to a rep or can you do the business end of things yourself?" There are many things you have to think about:
>
> 1. Twenty-five to thirty percent of your income goes to the rep.
> 2. Additional promo costs—Group promos ads (Showcase, Workbook, Blackbook, etc.), besides individual promos.

3. How good are you at negotiating prices? (I'm terrible, I would actually give work away so having a rep makes me money even with the 25–30 percent commission)
4. Do you trust the rep with your livelihood (income and business relationship)?
5. How good is the rep at motivating, marketing, and goal settings for yourself and the group?

Now, in the last few years the downward trend in spending and budget cuts have affected the way art buyers obtain art (stock art and cheap art). Having a rep may not be the best idea for everyone since every penny is cherished these days. Is it wise to pay someone 25–30 percent when you may be able to send e-mail, postcards, make personal calls, etc., yourself? I still have Kolea representing me just because I'm still too busy creating images—not only for art buyers in the print market but other ventures Kolea has ventured into. The positive aspect today of having a rep is having someone who can create business for you in a changing market and that is where Kolea comes into play. She is not only my rep but a business partner. You have to be able to adjust gears and adjust to the world around you; when things are slow in one area you have to explore more areas. I don't have the time, my time is spent just creating and having a happy home with the family and friends.

Effective Promotion Materials

There are many different ways to approach the design and production of promotional materials. And there is one wrong way: leftovers from your advertising or direct mail! They should be planned for personal sales correspondence and maximum-targeted impact.

PRIMARY PROMOTIONAL MATERIAL

First you'll need "primary" promotional material. These visual pieces are used most often for sending ahead to get an appointment, or for leaving behind after showing a portfolio. Most clients still prefer print promotions, though many designers now prepare electronic promos such as CDs in addition to the printed pieces or as additional portfolios.

Some production methods for primary promotion pieces include photographic prints, laser color copies, inkjet prints, black-and-white prints, and mounting any of these to card stock. These methods work best when you have a small target audience (or are just starting out and have very little money).

With a larger audience, you may want to invest in offset printed materials. They may cost more money, but are less labor in the long run and lower per unit cost than above. Design and quality of production is the key either way. You don't have to spend a lot of money for promotion pieces to do them well.

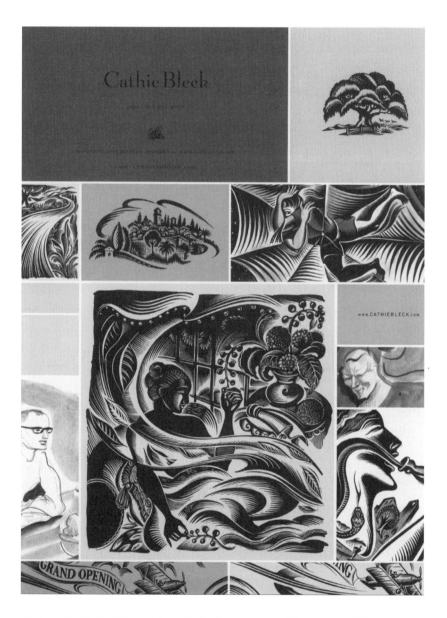

Illustrator Cathie Bleck hired designer Mark Murphy to create this very successful promo piece.

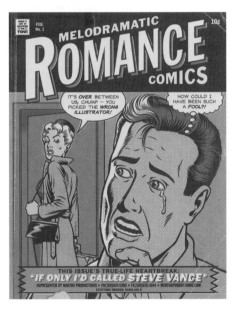

Rep Martha Spelman uses illustrator Steve Vance's promos to sell his strong style of work.

Illustrator Jean Tuttle shows a strong style and the classic marketing tactic, "name big, phone number big."

SECONDARY PROMOTIONAL MATERIAL

"Secondary" promotional materials are added once you have the basic visual materials for selling. Some of these production approaches include mini-portfolios, capability brochures, client-printed materials, and specialty advertising items.

Mini-Portfolios

The mini-portfolio is not really a portfolio at all. It is a sample given to a client to keep on file. The ultimate combination of concept, design, copy, and photography comes together to produce a real "keeper." It is a promo piece clients can call and ask for from your ads or direct mail. Good design and planning does not mean spending a lot of money. The most flexible format for a mini-portfolio is a presentation folder (add your logo label to personalize the cover) with inserts printed in advance and used as needed, depending on the client. This format is also the most easily used and customized for individual client cost-proposal presentations. Flexibility and convenience are the keys. Remember that the central issue in selling is understanding your clients' needs and helping them see that you are the one to meet those needs. Custom inserts help convey that individualized point. Today, creativity is the key to an effective mini-portfolio.

Jean Tuttle's spiral bound mini-portfolio.

THE

ILLUSTRATIONS

of

MARC BURCKHARDT

Combining wood, metal and other surfaces to
capture the texture and feeling of old, iconic
objects, a language of historical styles are used
to convey modern ideas and timeless themes.

Marc Burckhardt's mini-portfolio includes a verbal description of his visual marketing message.

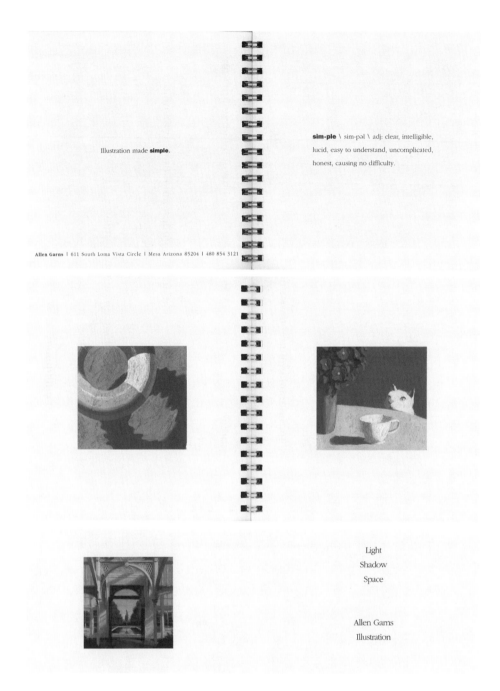

Illustration made **simple**.

sim·ple \ sim-pəl \ adj: clear, intelligible, lucid, easy to understand, uncomplicated, honest, causing no difficulty.

Allen Garns | 611 South Loma Vista Circle | Mesa Arizona 85204 | 480 854 3121

Light
Shadow
Space

Allen Garns
Illustration

Illustrator Allen Garns produced two mini-portfolios for Martha Spelman, Martha Productions—one for each style.

Stephanie Dalton Cowan produced and later sold her beautiful series of original photography and collage-art illustration books.

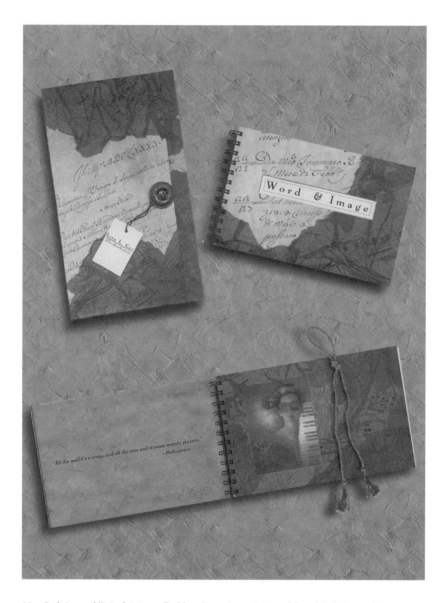

Lisa Cyr's journal "Word & Image" adds value to her mini-portfolio with design and copy.

Capability Brochures

A capability brochure can be combined with a mini-portfolio or used as a stand-alone piece. It usually is an information or copy-heavy piece that includes your marketing message, background, client testimonials, client list, facilities description, map to your studio and even equipment inventory. In addition, it can be packaged with cost proposals to help you get the job you are bidding for!

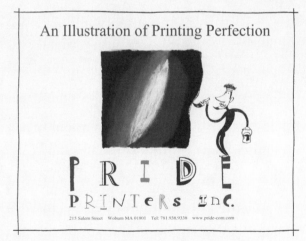

Greg Paul's capability brochure design for the BIG Illustration Group.

VISION

From artist's portfolio
14 x 18 acrylic on board

Illustration about the different
components involved to realize a
company's vision

HAVE A HEART
GIVE A HAND
United Way/Bank of America
Larry Braderer, Art Director
15 x 27 acrylic on board

Poster image for fund
raising campaign

ne·ot·e·ny (ne ot́ ñ e), *n. Biol* **1.** Also
called pedogenesis, the production of
offspring by an organism in its larval or
juvenile form; the elimination of the
adult phase of the life cycle. **2.** a slow-
ing of the rate of development with
consequent retention in adulthood of a
feature or features that appeared in an
earlier phase in the life cycle of ances-
tral individuals. **3.** the retention of
juvenile characteristics in the adults of a
species. [1900–05; < NL *neotēnia* < Gk
neo- NEO- + *tein*(ein) to stretch + *-ia-y²*
—ne·ot·e·nous (ne ot́ n ǽs), *adj.*

Joel Nakamura's promos demonstrate his unique capability by adding personal philosophy and
other attention-grabbing copy (see this page and the following two pages).

Nakamura's use of iconography and narrative symbolism make the work fascinating as well as accessible. Nakamura employs a balance of both personal and commercial commissions. The artist oftens finds inspiration for fine art projects from his commercial illustration. Says Nakamura, "With my assignments, there are always restrictions and deadlines, so I use my personal paintings to more fully explore these ideas. I find the interrelationships of both commercial and fine art paintings fuel each other to higher levels."

His methods and process involve a synthesis of sensibilities inspired from folk art, primitives, and an affinity with modern painting. The result is a type of modern folk painting reporting social and political themes, or talk about contemporary colloquialisms.

The figure is central, showing a unique depiction of man and his roles. Stripped away is the facade. The veneers of gender or race are removed, revealing an interior structure or dialogue. Cryptic drawings provide the narrative. Thoughts, bones, and objects take on psychological and conceptual undertones. The images ask questions and sometimes answer them.

The issues are not always obvious. The viewer is challenged to see beyond the rituals of banal activities and to dive into the primal instincts of the subconscious imagination.

Client-printed Pieces

Client-printed pieces create opportunities for self-promotion. You get the value of the equity in a "household name" client and, best of all; the client pays for the production. Depending on the client, you buy or negotiate a price to get from several dozen to a couple of hundred copies on the same print run. When a client is printing single sheets, you can check to see if you can get yours with the backside left blank. Then, you can get them inexpensively back-printed with your own promotional copy. This represents a "win-win" opportunity for you and the client and should not be overlooked.

Specialty Advertising

When you have done everything else, be creative and use a specialty advertising promo piece! Again, being creative does not mean spending a lot of money. These promo pieces tend to be best used for name recognition and reminders, rather than as traditional selling promos. They are useful items (pens, notepads, coffee cups) that you give to your clients. You can order from any catalog supplier of specialty advertising. Some creative ideas are note cards, pop-up calendars, and the ever-useful mouse pad or screensaver. Whatever you choose, make sure it echoes the marketing message of your primary promo pieces and is nice enough for the clients to want to keep! The quality of the specialty item will reflect on the quality of your work. For example, how many times have you tried to use a logo pen that either leaked or did not write? If so, what did that make you think about the advertiser?

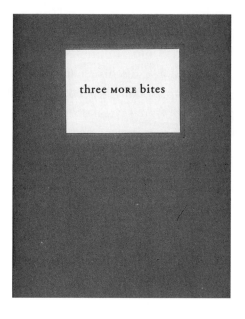

colophon

This book is a collaboration between
a writer, an artist, a designer and a
printer. The poetry is by Anne Telford
and is accompanied by Cathie Bleck's
scratchboard illustrations. The design
is by MOD/Michael Osborne Design
and letterpress printed by Norman Clayton
at One Heart Press using photopolymer
plates. The paper is BFK Rives Grey and
Somerset White Book. The type is set in
Adobe Garamond.

This edition is limited to 300 numbered
copies signed by Anne Telford and
Cathie Bleck.

159

Anne Telford

Cathie Bleck

©2001 Anne Telford/Cathie Bleck

anne telford

Anne Telford is a published poet and
photographer, and the managing editor
of Communication Arts magazine. A native
Californian, Anne lives in San Francisco
with her husband and their daughter.

cathie bleck

Cathie Bleck is an award-winning illus-
trator and artist whose work spans over
twenty years. She lives in Cleveland, Ohio
with her husband and their three children.

mod/michael osborne design

Specializing in corporate/brand identity
and packaging, MOD is also known for
its many promotional projects which incor-
porate letterpress printing and fine art.

one heart press

Established by Michael Osborne and
Norman Clayton in 1991, One Heart
Press continues the distinctive tradition
of letterpress printing. The shop produces
business systems, invitations, posters
and fine-press books.

A personal project collaboration with Anne Telford, Michael Osborne, and One Heart Press, Cathie Bleck sent this Limited Edition letter press printed book to forty of her top clients.

Jean Tuttle's memo pad for Valentine's Day.

Peleg Top, of TOP Design Studio, sends calendar pages after mailing the page holder for the calendar.

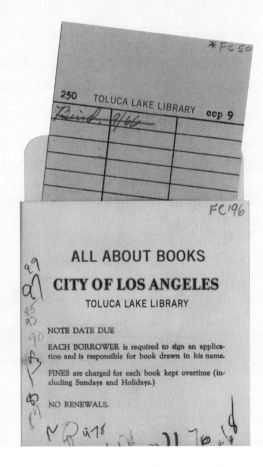

topic

the top design studio newsletter · *fall 2003*

TOP Design Studio also designs and produces a creative and interesting newsletter to keep clients up to date.

Rep Gerald Rapp's t-shirts for Think Illustration.

Rep Gerald Rapp keeps clients cool with fans from each of the illustrators with an image on the front and the illustrator's statement printed on the back.

CASE STUDIES FROM CREATIVE PROFESSIONALS
Eda Warren, of Desktop Publishing Services, adds:

I have a Web site and as a certified and authorized training provider, I get referrals from Adobe and Quark. I also advertise in a local learning guide to community classes of all types. Any design work that I get comes from my training clients. I'm good at getting template work because if they need design skill and don't have a designer, they are grateful for the help.

And I sell a unique product—templates almost sell themselves. They benefit the client in two very special ways. They get a professionally designed solution to their communication problem, responding to the unique problem definition of their message, their audience, and their objectives. This already makes my template a quantum leap beyond pre-packaged templates that are provided by software programs. Secondly, I give the client a file that is optimized for the production of that document, with all factors taken into account—file setup, master pages, defaults, standing items, and of course style sheets. I also do a session of template training and give them documentation of the process that is specific to their document. It's an unbeatable combination because they get to do the work internally and maintain control of the project, and I get the design and training business (without the headaches!).

A training client of mine once told me that their office had some big design firm make them a newsletter template (the decision was not in her hands), but unfortunately, the outside designer didn't know PageMaker, the program I had trained my client on, so after paying thousands of dollars for the design, delivered as printed proofs, no file, my client was asked to construct the template file herself!!

Notice how Eda created a "win-win" opportunity for her firm and her client on the heels of a negative experience from a competitor.

Here's another view from Cathie Bleck, of Cathie Bleck Illustration in Cleveland, Ohio:

I send very few promotionals, but when I do I try to make it something collectable or one of a kind. I also like to keep these promos for selective clients and it is a small list of designers for the most part. If I have to turn down a job, I try to make the effort to send some tear sheets as a follow up and a personal note.

I am also involved with an outstanding co-op of artists, *www.picturemechanics.com*, and we are promoting together through ads, gallery shows, and special promos. Being associated with quality work is vital to presenting ones work. I am also planning to take out a double page spread in Mark Murphy's "Heaven and Hell" book which will feature one hundred outstanding artists' works and will be marketed to museums, galleries, stores, design and advertising firms.

Lisa Cyr, accomplished designer, illustrator, writer, and lecturer was asked how she promoted herself to stand out from her competitors. Here's what she had to say:

In today's highly competitive marketplace, designers and illustrators are adopting a more strategic role when it comes to promotion. This is quite a shift from years past where promotional materials boasted a mere list of services along with a portfolio presentation. Today, the best creatives are showing prospective clients what they can do in a more inventive and thought provoking way. They are creating promotional pieces with perceived value—something that a client would want to hold onto and use. Books, calendars, and lots of collaborative endeavors are being explored with a trend towards an editorial sensibility. Brochures, from tiny flipbooks to multi-pieced assemblages, are much more storytelling in nature—captivating, entertaining, and engaging the audience. To create distinction, promotions have become more content-driven and much more effective as a result.

Portfolio Presentations

The highest goal of presenting your portfolio is to move yourself from the big pool of "unknowns" every potential client has interviewed to the pool of "knowns" they will hire. Help the client hire you! Don't just passively show your portfolio. Find out what your prospective clients are looking for in your portfolio and present that information. An interesting paradox: your message must be both visual and nonvisual.

WHAT CLIENTS LOOK FOR

Here are the things that clients are looking for when they view your portfolio:

Technical Ability

This is almost a given in today's marketplace. It is clearly seen in your work, and must be there. Since there are a lot of technically competent designers and illustrators out there, the "visuals only" are usually not enough information. No question that you must start there, but don't stop there!

Give the Clients What They Really Want

To make this happen, your ability to listen is crucial. Before you put together your next sales presentation, be sure to determine whether your client wants a creative collaboration with you, or has a more literal (and preapproved by committee) image. Peter Block's pioneering book on consulting relationships, *Flawless Consulting*, labels these as either the "expert" consultant or the "pair of hands" role. They are simply different clients; neither is wrong or bad. The style client that buys creative collaboration looks at your style, personal vision, your problem-solving skills, and the way you visualize. The more literal clients are very straightforward, know exactly what they want, and want to see what they need in your portfolio before they hire you. You can develop the ability to spot these differences, which will provide both you and the client with a much more successful working relationship.

Making Them Look Good

You do not have to explain what you are showing. Given the power of visual language, the work itself will tell the client "what" it is, so your job here is to let clients know the "why, who, when, where" of your work. Try adding success story anecdotes when presenting your work so that your client can better imagine working with you successfully. Once you've started this process, you are moving from the pure visual to the nonvisual presentation. For example, make short and simple statements of special interest that will draw the client into the work, e.g., "that was for clients launching their first new product in two years," or, "for this illustration we did extensive research on the topic of depression." This opens the door for more conversation when the

client is interested, plus it adds value to the idea of hiring you by adding more depth to the visuals. Keep listening carefully. Soon you'll hear ways that your expertise and experience can help the client succeed by hiring you.

Be the Aspirin, Not the Headache

Every client's dream project is the one that goes smoothly and eases client frustrations without adding headaches. Your presentations should address this issue because, whether they admit it or not, all clients are thinking of it. This aspect of your work is another nonvisual element of the presentation. Clients cannot tell from your illustration or logo design if working with you was a joy or a headache for your previous client. However, they can surely determine that from your verbal presentation. In addition, this case study approach provides a discussion point when the client makes the comment, "We are happy with our current freelancer and are not looking right now." In this situation there may be something the current designer or illustrator is not providing, or a service the designer/illustrator's firm cannot offer, that you or your firm can—listen carefully and be alert for that. Clients will remember this discussion when they find a need for your special style or services! Don't ever speak badly of the current designer or illustrator: that can be perceived negatively. Instead, pick up these cues and turn them into positives about your concern for future relationships and your skill in solving problems.

Work within Deadlines and Budgets

Again the case study, or anecdotal, approach to your sales presentations is the best way to demonstrate this factor. You have to provide "back story," especially when the prospective client is looking at your proposal, but not asking questions during a presentation. Clients cannot tell just from looking at a design or illustration whether you can work within deadlines or budgets. You have to tell them! You can gain a competitive edge when you can prove you can be trusted with the client's design or illustration needs.

PORTFOLIO FORMATS

As you will see in chapter 15, portfolio upgrades are part of the marketing plan and the format you present is an important element in these upgrades. You need to plan this activity because your portfolio won't update itself spontaneously. Also, get help from a rep, a fellow association member, or a professional consultant. Your portfolio provides the focus and direction for your business, but it is very personal and therefore it is hard to be objective.

For many designers and illustrators, portfolio presentations are not as effective as they could be because they are not well thought out. Many people show an accumulative collection of work they have done, hoping the client will find something they like. Wrong approach! The accumulation of all the work you have ever done is *not* a portfolio; it is your body of work. Out of your body of work you will pull various portfolios, based on your different marketing messages and based on the needs of each specific prospective client. Each portfolio you pull out of the body of work must target the type of client you want and the level at which you want to work (and not necessarily the level you are at now).

There are two major areas to concentrate on when planning your portfolio presentation formats. First, what you show in your portfolio, and second, how you show it. Before you do anything else, however, go to your planner or calendar and schedule the time to do this work. Overhauling your portfolio is not the kind of project you can approach casually. It should be treated like any assignment and be given a time and budget. For example, when will you start working on your portfolio inspection? How much time will you plan to spend? How often will you review what you show and how will you show it? Also, you'll need to decide how much money you will set aside for new portfolio cases or presentation boards. Since you are the client in this assignment, be generous! Give yourself enough time and money to do the best possible job.

WHAT YOU SHOW

As we have said, a portfolio is targeted to a specific audience. How do you define that audience? You define it by looking at the kind of work you want to do more of—also known as your marketing message. As discussed in chapter 1, it could be your personal style, the industry of the client, the use of the work, or the subject you are illustrating. Stay focused on your target marketing message.

What if you don't have this work to show? Sometimes the work you want to do is not the kind of work you have been getting. What if you are making a transition, looking for different types of assignments, better clients, or just starting out? How do you deal with the client that says, "But I want someone who has experience with my product"?

The answer is self-assignments. This is one of the most powerful concepts supporting development of new creative business, and one of the most ignored. The fact is that people hire you as a creative professional because of what you can do and how you think, not necessarily what you have done in the past for other clients (though you must get as close as you can with the more literal clients).

So, this means two things: first, create self-assigned material, and second, clean out pieces in your portfolio that don't support your marketing message. Follow a discipline of self-assigning items that you know will move you toward working in your desired personal style, creating in your desired industry, having your work used the way you want, or making work for your favorite creative subject. Build this up. Then, your clean-up job at this step is to pull out pieces from your portfolio that don't meet your highest level of creativity and technical ability. Paid jobs may not reflect your best work. Let's face it: all designers and illustrators have done work within budget or creative restrictions that keep them from doing their finest work. Don't show it! Never include a piece in your portfolio just because you got paid to do it. Once you pull all of the "don't show it" work (be merciless), you can more clearly see where the holes are in your portfolios that need to be filled with even more self-assignments.

What to Show in Your Portfolio

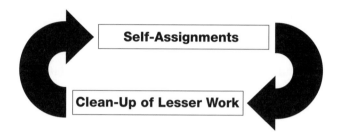

Keep the Cycle Moving

For example, if you want to do more annual reports, you need to create self-assignments built around the problems and solutions you would find with a corporate communications client. If you want to do more Web design assignments, build your portfolio around a real (or made-up) e-commerce firm and produce a Web portfolio project to promote this company. Self-assignment work is not personal work. There is always an intended client and their problem—along with your solution.

HOW YOU SHOW IT

First, how many different kinds of portfolios could you create? Depending on what you are selling and whom you are selling your design or illustration services to, you could create as many as three different portfolios.

First, the "show" portfolio is your personal portfolio that goes with you to all your client presentations.

Second, if you need to send a portfolio to an out-of-town client, you will need duplicates of the "show" portfolio. These "traveling" portfolios should be smaller and lighter for shipping purposes.

Third, sometimes a local client will ask that you "drop-off" a portfolio so he can easily evaluate whether he wants to see you and

the full "show" portfolio. This "drop-off book" is a partial portfolio designed to give the client an idea of what you can do. It will have perhaps five or six images of your marketing message in it. It should only take a small number of images to help clients make this decision, and these works should be bound into some kind of book so that nothing gets lost. Ringless binders or albums would also work well for both the traveling and the drop-off portfolios. CDs or DVDs are other great options.

TRADITIONAL PORTFOLIOS

If you are the kind of person who buys a new portfolio case by whim or by what is on sale, stop and consider the impression you are making. You never get a second chance to make a first impression. Clients get an immediate (often indelible) image of you at first glance. Some clients may not care about this, but most will.

Your portfolio case should look like extension of you, not something that you haphazardly picked up and put together. Look for a case that has some personal distinction. A custom case manufactured specifically for your work is one of the best choices. You choose size, color, and materials along with your name or logo added to the outside of the case. If you decide to shop at a local art supply store, buy the more expensive and classic leather, rather than the cheaper vinyl, or ask to look through their suppliers' catalogs for something just a little different or unique! Don't overlook the possibilities that luggage store outlets may offer for a choice of portfolio cases.

On the inside, go for quality and professionalism. It is possible clients will assume that if your portfolio is poorly produced or presented, the work you do for them will also be poor. Worn mats, tired-looking transparency sleeves, scuffed CD cases, poorly printed CD inserts, and unmounted presentation pieces must be taken care of immediately. Resist the temptation to just throw something into a portfolio, "just to show it." It's a poor excuse for an incomplete presentation.

One of the first decisions to make is whether to show your traditional portfolio as reflective art or as transparency. Either one can be

laminated or mounted, but they don't mix well. It's really a personal decision based on your budget and comfort levels. Also, consider using the one your prospective client is most comfortable and familiar with. If you don't know what clients prefer, ask them! If you choose reflective art, inkjet prints are the most popular choice and you can have a custom photo lab laminate or mount them if they are not going into a book or binder. If you choose transparency, the same lab can do film instead of print. It is also a sign of professionalism to have your name or logo on each lamination or mat board. In addition to looking professional, repetition helps the client remember who you are.

What size should your traditional portfolio be? Most traditional portfolios shown or shipped today are in the range of 8" × 10" to 11" × 14". However, this is just the size of the outside of the mat board or lamination. All of your portfolio presentation boards should be the same outside size and then, inside this dimension you can mount any size or number of images. For example, an 11" × 14" board could show one annual report cover or two package illustrations or four logo designs.

How many pieces should you show? Remember, your portfolio is not a complete body of work. The entire collection of pieces could be dozens or even hundreds of images. Any given traditional portfolio should be a selection of ten to fifteen boards or laminations selected for a particular client. Because each board or lamination could show two or more images, this keeps the portfolio quantity manageable while not severely limiting the number of images you show.

ELECTRONIC PORTFOLIOS

Given their current popularity, will electronic portfolios replace traditional portfolios? As a rep, writer, and professional speaker, I am constantly asked this question. Personally, I always get my reality check from my prospective clients by asking them! Remember, your format needs to be in the prospective client's comfort zone. You should not ask a prospective client, "Can you view a CD or Web site portfolio?" Of course they can, because it is physically possible, but

you asked the wrong question. Instead, ask, "How willing are you to look at a CD or Web site portfolio?" Also note that I am referring to your prospective clients, not your current clients. Their answers may be different since they already "know" you.

Once you know where your prospective clients stand on electronic portfolio review, remember that technology is only a tool, and you still are a designer or illustrator. You still need a marketing plan for your portfolio decisions. How much you invest in electronic portfolio will be finally decided by asking yourself these two marketing questions. One, what are you selling? Two, whom are you selling to?

First, what are you selling? Designers and illustrators can market themselves (and create portfolios) based on two different criteria. One, you could focus on the work itself: how your design or illustration skills are applied. Clients then hire based on your expertise in the work they need. These could be traditional design or illustration requirements such as corporate identity; collateral, annual reports, or packaging design—and these clients may still need to see more traditional portfolios.

Then there are projects such as Web sites, CD-ROM products, trade show kiosks, video games, Internet ads, and multimedia presentations. You will then have an advantage by using electronic portfolios, because the clients are already using the technology as a product or as a promotion tool themselves.

Second, whom are you selling to? Here your focus and portfolio is on the type of client or industry. The type of design or illustration work you want and the type of client for that work will determine the advantage or disadvantage to you of an electronic portfolio. You will then determine which are the more conservative industries (such as healthcare or financial) versus the more technology driven industries (such as computer or entertainment).

When you decide to create an electronic portfolio, you will need to standout from the crowd of CD, DVD, and Internet clutter. The technology allows you to create customized portfolios better, quicker, and more cost-effectively than you can with traditional portfolios.

Here is a checklist of ideas for designing a job-getting electronic portfolio:

❑ Add the prospective client's company name to the presentation
❑ Include the name of the individual looking at your work
❑ Offer duplicate copies so your work can be "approved by committee"
❑ Include project names you may have discussed with the client
❑ Plan for follow-up. Will you next show new work or a different format?
❑ Include self-assignments in your follow-up portfolios based on the client's reactions to the first presentation.

After all, the goal is to create a portfolio to get new work. Help the client hire you!

Pricing and Negotiating

Pricing is something many creative professionals are unfamiliar with and have some anxiety about. That is understandable; there's some truth to the belief that everything you do and say at the beginning will be carved in stone and very difficult to change later. However, it's not that hard to get off on the right foot with a new client, so long as you have a clear strategy in mind.

PRICING RULES OF THE ROAD

Here are some tips to help you get it right from the beginning:

- **Remove the "you" from the picture when price comes up.** It is difficult for most of us to price "you." Talk about what "it" is worth or what "the project" will cost, not what "you" charge. No matter what the project is, making pricing too personal reduces your objectivity and ability to negotiate. It's about the value the client will receive, not about "you."
- **Use industry standard forms with legally accepted terms and conditions and know your industry business practices and standards.** If a client starts off abusing you on price or copyright because of your lack of education, you'll never be treated fairly in that relationship. Don't reinvent the wheel for an estimate form when dozens of association

lawyers have already designed the forms to protect you, for groups such as Graphic Artists Guild (*www.gag.org*), American Institute of Graphic Arts (*www.aiga.org*), or Society of Illustrators (*www.societyillustrators.org*). Get your relationship off to a professional and business-like start by using professional forms.

- **Determine if you are in a competitive or comparative pricing relationship from the beginning.** There is a very big difference. In a competitive bid, the client (often government) hires the low bidder. In a comparative situation, the best person or firm for the project gets the job. Neither is good or bad; just know what kind of situation you are in.
- **Find out who is really in charge and if the person you are dealing with has both the responsibility to find you and the authority to hire you.** Learn the negotiating scripts below and use them wisely. Review the techniques in this chapter on how to put everything in writing, including the benefits of working with you. To get your price, learn to package your price.

NEGOTIATING YOUR PRICE

Don't quote prices off the top of your head! It's very, very rare that a fair price can be determined before the project scope is fully described and understood. Plan on calling the client back after you get the project description. This is most important when you don't know the client or don't know if you have the job for certain. Always ask when would be the best time to call back. Often, clients have much more time than you feel they do, and you will need the extra time! This will give you the chance to do an accurate cost estimate and shows your client respect for their request of your creative services.

Get complete and detailed project information. It is impossible to get too much information, you may need it later to negotiate and you will need it to accurately quote a price.

When you call clients back, use scripting to get some feedback on that mysterious budget figure they probably didn't tell you. This feedback will help determine exactly how much work you will put into your written cost proposal.

Prepare this verbal presentation script in advance so that you can handle any response. For example, when you ask, "What you described will cost $5,000. How does that fit your budget?" the client will respond positively or negatively with information you can use to take the next step. If clients respond positively, then you go to the "packaging your price" step. If they are negative about your price, then you go to "considerations to negotiate" and, before you put anything in writing, discuss considerations until you and your client agree the price is now "in their ballpark."

CONSIDERATIONS TO NEGOTIATE

Before the final step of presenting a nicely packaged cost proposal, you may want to discuss and negotiate your price. Again, if you don't know the client or if you don't have the job, this is an important step. Your regular clients do not usually need all of this effort. When you quote a price, there are only a few possible outcomes:

- The client says, "Sure, that sounds fine."
- The client says, "I can pay more money." (Okay, that is a rare occurrence.)
- The client says, "I don't have that kind of money!"

So what do you do when the client wants to pay less? Answer: you walk away—or you negotiate. A great old saying: "In business, you don't get what you deserve, you get what you negotiate." There's nothing wrong in deciding to walk away, but I do not accept the notion of dropping your price without negotiating some consideration to the project description. In other words, less money might be okay, but fairness demands that it be for less of something else. Graphic design and illustration are not products pulled down off a shelf.

So, never drop your price for a specific job description without some consideration made by you or the client. Not only is it unprofessional to do so, it makes your client doubt the value of your work or the credibility of your price in the first place! In addition, you'll probably lose money (and some self-esteem) on the project and that client will try to get the next creative professional to drop his price without rhyme or reason. Worst case, the client will tell all of his friends he found a "cheap" designer or illustrator and you will never get paid what you're really worth. You can always walk away if you are not willing to negotiate or the client simply can't come close enough in negotiation to what it really costs to do the work.

Another common situation is when the client says, "I can get it for half price from someone down the street." To demonstrate that I am a professional, I usually ask a simple question, "How is that possible?" The client usually has to stop and think about it. What I am really asking is, "How can this much work be done for that much less money?" Another way for clients to interpret my question is, "What will they get less of, and do they want to know now or be surprised later?" This is a very important opportunity to educate a creative services client; don't miss out on it!

The beauty of creative services is that you can assure the client that graphic design and illustration done for less than the fair, normal, and industry average price will invariably look like it. Factors that go into pricing include experience, expertise, and equipment. Other factors are the importance of the creative professional's time, energy, and attention. Help your clients or prospective clients understand further the importance of fair pricing: ask them to consider what it would cost them to pay less. Sure, they can pay less money for a design or illustration, but what will the "hidden cost" be? When they want to go ahead and hire for less money, clients need to look at the added (and usually discovered later) costs of their own time, energy, attention—even their prestige and esteem.

"You pay less, you get less—and that might work for us both." When the client's budget is close enough for you to think of doing the

job, look at considerations to negotiate. Certainly take any and all negotiating seminars and classes you can find, but you must learn at least this one technique. It is a simple concept to use and explain. For the client to pay less, the client will get less of some aspect of the project description that you both agree to or you will get more of something valuable to your business. Simply put, when the client names a price lower than what is acceptable, your answer is any variation of "Let's take a look at how it can be done for that price." This is a dimension of "win-win" negotiation.

Next, you look at two lists you have put together in advance of this meeting or discussion. One is a list of the considerations the client can make to lower the price. For example, clients can get less usage rights, fewer personal consultations, smaller quantity of pages or images, less thumbnails, or fewer approval stages. Anything you can think of that will help the client pay less without damaging the project.

If you need to, go to your second list. These are the considerations where you can get more of something for the client to lower the price. To do the work for less money you can get more time, more printed samples, or better payment terms. Work on this today! Your negotiations are simpler and easier when you have lots of items to choose from on your two lists.

The bottom line is you do not accept less money for the same amount of work. You will damage your chance at a profitable relationship with clients. You will give your work away. Don't do it. Instead, look for the "win-win." Learn successful negotiating techniques to get the best return on your creativity and your business. Here are suggestions for your two negotiation lists:

Client "gives":
• Less usage rights
• Fewer personal consultations
• Fewer pages
• Fewer images

• Less thumbnails
• Fewer approvals

You "get":
• More time
• Better payment terms
• Increased usage rights
• Better "credit" of your name, print, or Web site
• Increased number of printed copies

PACKAGING YOUR PRICE

It's ironic that creative professionals often forget Marshall McLuhan's famous saying, "The medium is the message." A thorough presentation of your project quotes that will illustrate your professionalism and expertise can help the client decide to hire you and come back for more! When you and your client have a price you both agree on, or when you want to gain a marketing edge over your competition, you'll find that a good looking presentation of the price can make the difference between getting the job or not. Whether you are doing graphic design, illustration, or anything in the creative professions, an irresistible presentation of your price will best demonstrate your professionalism, value, expertise, and abilities. This will help the client decide to hire you instead of a competitor. In addition, this beautifully prepared proposal demonstrates to the client the extra value they will get for the price they will pay, and the attention to detail you will apply to their job.

Remember, unless you know you already have the job, you may need to give the client more information and proof than the typical estimate confirmation (contract) by itself provides. More importantly, the person you call "client" probably has to get your estimate approved and needs something to show around in committee to help you get the job. After all, the estimate confirmation just tells clients what it would cost to hire you, but the packaging tells them why it is such a good idea!

Here are the typical elements to prepare a more creative and job-getting proposal: the estimate confirmation form, a cover letter, samples that relate to the project, and testimonials or any third-party endorsement for added credibility. Let's look at each in more detail.

THE CONTRACT

As mentioned above, the contract is commonly called the "estimate confirmation." It is most effective to print the contract information on your own letterhead to look as professional as possible. Use the industry standard forms discussed above, with customary contract law for either graphic design or illustration, to protect you and your client.

Very important: get the correct name of the person with the authority to hire you and pay you. Does your client have the responsibility to find you, but needs further approval to hire you? If your client needs the approval of a supervisor or CEO, make sure that both people get original copies of your proposal.

If you are dealing with a third party—i.e., *your* client is an ad agency and there is a third party, which is *the agency's* client—make sure you get the contact information for the person or people who are in charge. For example, ad agencies get lots of freelance design and illustration estimate confirmation forms, and you want yours properly considered for the correct project.

Remember, since any alteration in the project could cause an increase in expenses, a detailed job description, or scope of work, can avoid the problem of going back to the client for more money to produce what was wanted in the first place. If the unexpected happens (and it almost always does), have estimate amendment forms available for changes to the fee or expenses approved by the client during the job.

Creative fees should include a complete statement of the usage of the design or illustration. Again, go back to the business basics of copyright discussed in books such as *Graphic Artists Guild Pricing & Ethical Guidelines* (*www.gag.org*), *The Copyright Guide, The Law (in Plain English) for Small Businesses, Business and Legal Forms for*

Illustrators, and *Business and Legal Forms for Graphic Designers* (*www.allworth.com*). You must never leave the client in legal jeopardy. Ask clients what their plans are for the design or illustration use and re-use. If they ask why, be sure you tell them that you want to make certain they are getting the proper license or transfer of rights they need. You are trying to protect them!

A new factor in today's marketplace is to find out which budgets can be dedicated or diverted to your part of the project. Often, a fee is set aside and named the design or illustration fee but that is just one (small) line item on a very big project budget. Often, you are getting into a project sooner and leaving later than the fee structure may account for, so to maximize profitability, ask! Whether it is an advertising illustration, Web site design, or a catalog project, technology today allows you to be more involved in the creative process but client's budgeting allocations have not always accounted for this critical factor. There are often other line items named in that project budget that really should be redirected towards your fees and expenses. Have the client check on items such as preproduction, research, any and all retouching, postproduction, and prepress, to name a few. The money is there to pay you for the extra work, but you will probably have to help the client find it for you.

Expenses can only be estimated, and your estimate form should state that the client agrees to pay actual expenses. Industry standard variation of 10 percent above or below the estimate is customary and should be stated on the front of the contract, but I would still recommend you get an estimate amendment if the price goes up. This establishes your concern for the quality of your relationship with the client, and it's all about relationships. No one likes surprises.

State clearly what your price includes so that your client knows exactly what he is getting. Client changes or additions, delivery costs, and output (what exactly they will receive) are three of the most overlooked issues. Standard contracts should state that clients will pay for any changes or revisions they make to the original project description. Don't let any unnamed or additional expenses come out of your

fee. Calculate the delivery charges, special research needed, extra scans—any possible expenses for the assignment. Then itemize them. The more detailed the description, the less you risk absorbing any of these client expenses.

Deposits or advances should be discussed. A deposit is a percentage of the total cost (from 30 percent to 50 percent) that the client pays to confirm the assignment. An advance is a prepayment for costly or extraordinary preproduction expenses. Try to get either an advance or a deposit. You are not a bank; you are a creative professional. Though your invoice should be paid when the work is delivered, most are sent to your client's accounts payable department, so ask for payment "net receipt." This should get you paid within thirty days. Then, a late payment charge (usually around 2 to 3 percent) should be quoted on all jobs. It is customary for the client to pay any legal fees, if needed, to collect money. All of this information is already in your industry-standard estimates and invoices "terms and conditions" section.

THE COVER LETTER

A good cover letter warms up that otherwise cold-looking contract. It will help your client (and their committee) decide to hire you. Here is an example of a cost proposal cover letter.

Dear David,

It was a pleasure talking with you yesterday about your annual report project. As we discussed, enclosed is the estimate confirmation for the graphic design and illustration elements of the project our firm will provide.

In addition, we have enclosed the custom print samples and CD of our work that you requested to present to your communications committee. You'll find our style and techniques will be exactly what you need for a smoothly completed project.

Also, when you are ready to proceed with the design and illustration for that upcoming trade show, we will work with you to continue this "new look" you will need for your company branding and marketing value.

I'll call next week to find out when you will be making a final decision on this job. We are looking forward to working with you!

Sincerely,
Maria Piscopo

P.S. Please let me know if you have any technical project questions or need any additional samples of our work as you review the proposal.

———

SAMPLES OF YOUR WORK

You should include samples of the work you will be doing. Let's say in this case, the client is interested in annual report work and in a particular style. He also expressed a concern that your cover letter reflects the consistency of his brand. So, without doing spec work, show you can do this work by providing examples. Yes, you may have already displayed these, but never assume the client will remember what he saw in your portfolio or that he pulled your promotion materials from his files or revisited your Web site.

Clients may do these things, but count on having to visually reestablish your creativity and technical ability to do the work. This will help you get the job, and help the committee of people involved decide who gets hired.

ADD CREDIBILITY

In addition to your contract, cover letter, and samples, you can add credibility by submitting third-party proof of your capabilities. This may be the deciding factor to help the client decide to hire you. More likely, your client may need these items to certify your reliability, so he can sell you to his own committee of decision makers.

Examples of third-party proof of your credibility include testimonial letters from satisfied clients, awards you have won, exhibits of your work, a list of clients, client references, and professional organizations you belong to. Anything you can do that will give you additional value and trustworthiness and help the client make the right decision—to hire you!

PRICING CASE STUDIES AND STORIES

Michael Fleishman of MCF Illustration, and author of *Starting Your Career as a Freelance Illustrator or Graphic Designer* (Allworth Press), is former president of the Graphic Artists Guild's at-large chapter and a commercial arts instructor (Edison Community College, Piqua, Ohio). I asked him for his most successful price negotiating tips and techniques, and here's what he said. Notice his metaphors to the "dance of negotiation":

> Get all the facts and specifics up front. Negotiations should be rooted in information and needs—based on both parties' needs . . . not just yours, not only theirs. Basically, it's "Here's what it takes to do this job. . . ." This you'll compare to the client's response, "Here's what we have; can you do it at this price?" Be sure you know the factors that nudge you to yes—or no—regardless of the money. And do you have a clear sense that no means just that?
>
> But fee is just one step in the pricing waltz. Many moves make up the dance and all must be considered for a fluid, graceful twirl around the dance floor of the assignment. Rights and usage, deadline, complexity, audience, the clients themselves, the job itself, the working relationship. Sometimes, it's pure gut feeling (don't ignore this, or simply dismiss it) that makes or breaks the deal.

Fleishman said that the most common mistake in negotiating is ". . . not asking for what you really need or want; not asking what the client really needs or wants." Clearly, then, you will not get what you do not ask for.

Michael's advice to a young professional struggling with pricing issues is:

Live and learn. This negotiation won't be your last; in all likelihood, this present negotiation won't demonstrate your worst or best efforts. Recognizing that you will live to negotiate again is a solid, valuable learning experience in itself (and keeps your perspective real). Buy the [Graphic Artists] Guild's *Pricing and Ethical Guidelines*, current edition, immediately. If I were marooned on a desert island with my client and could only have one book (besides that copy of my new book I keep in the hidden compartment of the life preserver) this would be the one—the pricing and business bible for arty commercial types.

Ed Brodsky, partner at Lubell-Brodsky, Inc., affirms the importance of writing a good proposal:

Perhaps the best pricing technique we've ever discovered is to write a good proposal. We have found it's best to start a proposal by first restating the criteria for the project. This reminds everyone, including ourselves, what it was we agreed to try to accomplish. Next we explain what we plan do, and plan to do it in broad general terms. Then we usually follow this with a more specific list of work we intend to do, a price for each of these procedures, and a total. We almost always end the proposal by telling the client how excited we are to be considered for this interesting project and some of the benefits we expect the client to realize from our efforts.

Perhaps the biggest advantage of writing a good proposal is that after we write it we often realize that the project can command a much larger fee than we initially thought. This more than covers the cost and time of writing the proposal and also has become the main reason we have successfully been able to raise our fees.

The most common mistake creative professionals might make is not to have a plan "B." That is, a plan that will justify a lower fee for less work. We try never to indicate that we will do the same amount of work for a lesser fee, that our fees are negotiable, or, worse yet, arbitrary.

When struggling with pricing issues, we think it's a good idea to have a per hour rate in mind for your work. When clients ask,

"How did you come up with a particular price?" you can tell them how long you estimate the job will take, multiplied by your hourly rate. Many clients understand this method of setting fees. Their accountants and lawyers have always charged them by the hour.

Ed concludes on a very encouraging note:

As for education, I don't think it's necessary to take bookkeeping courses. Basic math is all that's needed. Leave the rest to the accountants. However, reading books about negotiating techniques such as *Getting to Yes* can be very helpful in learning to deal with clients about pricing issues.

Don Sparkman, President/Creative Director of Sparkman + Associates, Inc., has authored two books, *Selling Graphic Design* (in its second edition) and *The Design & Printing Buyer's Survival Guide*. Allworth Press in New York published both books. *Critique* magazine selected *Selling Graphic Design* as one of the top eighty-five books for designers written in the twentieth century. Here are Don's tips:

Most of our major projects come from bid situations against similar studios. If a project has been done before, I ask the prospective clients what they paid for this same project last time. (I explain to the prospect that this will keep the price from going higher and often drive it down). And having this information gives me an edge over bidding competitors.

The most common mistake is designers or illustrators don't ask for a retainer or percentage up front. They often don't specify what their fees are for. For instance: Their proposal states that Logo/Logotype Design is $10,000. Fine, but they don't say how many ideas they will submit, etc. The client can look at this estimate or cost as, "How long is a piece of string?" Because you have not defined the work (how long *is* this piece of string?), you could be asked to design round after round of ideas. If the designer tells the client that he has used up the $10,000 the client can say, "No, you said you'd design my logo for that price and you haven't done that yet."

Don concludes with a "live and learn" story that teaches a very important principle:

> I had to sue a client over [a logo I designed for him]. It's not in use now and it belongs to me. I don't mention the client's name—but it's a beautiful example of getting stung with no money up front, and then correcting the situation. I designed the logo and presented it to my client. He said he loved it and asked me to send a file of the art to a printer doing a charity program that he was advertising in for charity. The logo was reproduced once, and then the client said he didn't like the design and wouldn't pay for it. My lawyer obtained a copy of the printed program with the logo in it and when confronted with it, the client knew he had to pay my bill.

Ask yourself how, if you were in Don's shoes, you could have avoided this outcome with a more thoughtful estimate confirmation.

Gunnar Swanson, Gunnar Swanson Design Office, *www.gunnarswanson.com*, recommends five things when you negotiate price with a client:

1. Leave yourself room to do less. If you give a proposal for, say, a trademark design for a given price and the clients come back and say "How about 75 percent of that price?" and you say yes, then you have told them that your pricing is arbitrary and you will do any job for less than your bid. If you instead say "I can do it for that price but instead of getting six roughs to choose from you get three and instead of refining two, I will refine one." Then they can still make a deal with you but they don't have to bargain you down on every subsequent job.
2. Make sure that you know your point of indifference. If getting paid fifty dollars for a job would be insulting and getting paid fifty thousand would thrill you, there has to be a place in between where you would be just about as

happy not getting the job as getting it. If you know that price, it makes it easier to walk away when someone offers you less.

3. Make sure you understand the approval process and, if you're not talking to a company owner or CEO, don't take on face value any assurances that the person(s) you're dealing with can approve everything. Ask again and put the approval process in any proposal or contract if there is any doubt. A job that needs to be approved by one person will take a lot less time than one that needs to be approved by a committee and there are few better ways to sink a design project than to have someone who wasn't at the meetings (or, worse yet, someone you've never met or even heard of) suddenly second-guessing earlier decisions. Make sure you involve everyone who has any voice in the decision directly, even when it's easier to just deal with the one person who "speaks for everyone."

4. Sometimes you can't deal directly with real decision-makers. This is a bad situation. Charge more and write even tighter proposals or leave the job to some other sucker.

5. Never take a job where you'll resent having done it because of the price.

Gunnar then cites taking things personally as a very common problem. Since creative work can be an extension of you, this is very tempting. However, avoid this trap:

[Don't take] money negotiations personally or be shy about talking about money and getting what you need out of the deal. Most of your clients sell stuff. They figure out what it cost them or what its worth on the market. If someone wants something cheaper or can't afford their product, they don't think that means they've been insulted. It may just mean they were talking to the wrong prospect.

Why do graphic designers assume that someone saying no to a price means "Why are you wasting my time? You're not worthy"? (If you make a sale every time you talk to a prospect you either have otherworldly powers or you aren't charging enough.)

Years ago I offered a new client a choice between paying me at an hourly rate or paying a set price. (I wouldn't do that again. When someone is used to working with you, an hourly rate can make sense. When you're first working for a client they only care about a total, not a rate. If I charge twice as much an hour but do the thing in a third of the time, I'm a bargain. If I charge half as much an hour and take three times as long, I'm not.) He suggested an hourly rate with a cap of the set price. I said I wouldn't be interested in that since either I'd do the job faster than I guessed and I'd lose or I'd do the job more slowly than I'd guess and I'd lose. He replied, "I wouldn't have gone for it either but it's my job to ask." I suspect that if I'd taken the bad deal he would have thought I was an idiot and wouldn't have been as inclined to take my advice on marketing issues. As is, he turned into a good client; his company paid my mortgage for several years.

Also, if there is something you want or need out of a job, make sure it's in your proposal. For instance, if you are doing a job for slightly less money than you might get normally because you want a bunch of good printed samples, make sure that you make the copies part of the deal and specify that the printing be of whatever quality you need. Really figure out what your time costs you and really figure out how long things will take you. You will discover that a good hourly wage is much too low of an hourly rate for an independent business. You'll also discover that you'll spend more time on meetings and phone calls for a project than you thought you'd spend on the whole project. If you do what sounds good at first, you'll go broke.

Finally, if you ever think, "I shouldn't be doing this but [insert your explanation of great opportunity here]," remember that the important words are "I shouldn't be doing this."

Liane Sebastian, author of *Digital Design Business Practices* (*www.allworth.com*), is a twenty-five-year veteran of the graphic design business. She heads MichaeLight Communications, a design firm specializing in corporate identity and publishing. She was the founder and owner of a predecessor design firm, the internationally acclaimed Synthesis Concepts. Her clients have included Andersen Consulting, Borg-Warner, Helene Curtis, and Hyatt International:

> Pricing a project isn't as tricky as getting the price—either through negotiation or through project management. My pricing advice: Know your overhead, and what you need to keep the office rolling and profitable. With that knowledge, your prices have conviction.
>
> Know what the competition is charging and what the market will bear to find the right matches. Be willing to walk away from the wrong ones, with the confidence that better clients will come if you continue to look and do not lose money with bad matches.

Time and Stress Management

Creative people have to find a balance between business and creative issues in their lives. These issues cause mental conflicts for most professionals. For example, where do you find the time both to promote your work and create your work? What are the best techniques for managing everyday stress? How do you balance the goals of a professional life and a personal life? When do you assert yourself and when do you say, "whatever the client wants"? Finally, how do you balance project management deadlines and client approvals with doing the best possible creative work?

You need tools. Tools to work with you and for you. Tools that will give you more time to do your work and make your work less stressful. You need time- and stress-management tools specifically designed for the creative professional!

FINDING MORE TIME

You know that any activity expands to fill the time given to it. So, unless otherwise managed, your day will fill up with many things to do other than the business of running a creative business. Because of this, you must find the time to do everything you *need* to do (managing the business), want to do (personal activities), and *have* to do (client projects). The time is there. All you have to do is uncover it. Time can be buried in a number of different ways. I'll bet these sound familiar: You give priority to tasks that are agreeable and then have no

time left to do the less enjoyable, but maybe very necessary chores because your day is "full" and, "it's fun!" A different side to this problem is doing tasks that are "easy." By doing all the easy things first, you bury the time for the bigger and harder jobs because you are waiting to find the time. Another one, "it's here"—doing whatever is in front of you without regard to priority or level of importance, half the day is gone and you don't know where it went. Now that you are aware of how you hide the time, let's look at how to uncover it.

- **Take your marketing plan and your business plan along with your daily calendar and transfer every item onto the calendar.** Be sure each item is specific and manageable (as in bite-size tasks) and be careful to allow enough time. Do you know how long it takes to pay bills? Process the daily mail? Write a press release? When you schedule these things, you'll quickly find out. Don't forget vacations and holidays!

- **As things come to your attention during the day, you will either handle them immediately and completely or you will schedule the handling of them.** For example, the Ad Club calls you to discuss the upcoming Walkathon Fundraiser. Rather than drop what you are doing that moment to meet with the committee, use your calendar to find a time more appropriate to deal with this request. Now when the ABC Healthcare Company calls you to request a project consultation and they want "something different" for their annual report, you will have a calendar of items already scheduled, but the nonclient tasks can be rescheduled to take this meeting. Because everything is on the calendar you have the best of both worlds, and you will get both client and nonclient work done. No more lists of things to do that never get done—instead, schedule it!

- **You'll need a tickler file: an important time-management tool to work with your calendar.** Put together a file of thirty-one folders numbered #1 through #31. Keep these folders right in the deep drawer of your desk.

The "Tickler System"

Numbered

Go

. . . where you can use them daily

Though there are computer programs and personal digital assistants (PDAs) to track tasks, there are still often pieces of paper to keep track of! Then, as each paper crosses your desk, you have a place to keep it. With the above example, you find some time on October 30 for the committee meeting, you'll write "Ad Club Meeting" on your calendar for October 30, and put all the information pertaining to this in the folder numbered "30". No more piles of paper!

The key to this method is to handle everything you touch only once by dealing with it immediately or scheduling time to deal with it. This will not only help you find more time but will do two other things important to a creative services business: One, instead of waiting to find the time for marketing and management (and you never will), they simply become daily chores. Two, instead of getting depressed when you have a blank calendar, you will always have a task to work on that will help you move towards business success.

David Veal, illustrator (*www.blackbook.com/veal, www.theispot.com /artist/dveal*), says that he finds the time to both promote and create his work by making his work his marketing tool:

> As I complete assignments I file the imagery, drop it into my next directory ad, or write a promotional release for clients and prospects. The promotional release is a boilerplate information form that is either e-mailed directly to prospects and clients (with imagery inserted as a low resolution jpeg), or is e-mailed to my standard list of trade publications/organizations. When I do, this work finds me.

Gunnar Swanson finds that reserving time for promotion and creativity is critical:

> You have to make the time to do promotion—sales as well as general PR. The hardest thing is to take the time when you're busy but if you don't, you'll end up in a cycle of being busy, the bottom dropping out, a long period of promotion with no work, and then getting busy again until the bottom drops out. . . . A constant flow of work (to the extent that's possible) requires a constant flow of promotional work.

Peleg Top, Top Design Studio (*www.topdesign.com*), says that it's not a matter of finding time:

> The time is always there. It is up to me to arrange my time according to the needs and to know when to give what its priority. Promoting our work and the self-promotion items we create are a part of our weekly job logs. We treat each promotional item as if it was a client project, give it deadlines, assign tasks, and complete it on time and within budget. We generally plan the year out for our promotional efforts and schedule pieces to go out on a marketing calendar. It helps to get an overview of the entire year at a glance in order to be able to budget the time accordingly.

Peleg's organization is a key to his success in conquering time. He also carefully disciplines his personal habits for the same reasons:

I start the day with ten to fifteen minutes of meditation; I exercise three times a week and don't drink coffee after 10:00 A.M. Yoga helps as well. I try to practice it regularly. Generally, I don't tend to let things get to me too much. Clients and deadlines come and go but when it comes to our health, that's a priority. Vacations are also important. Besides a three- to four-week vacation a year, I take Fridays off and spend the day doing personal things that inspire me and energize me. As a side note, we never stay beyond 6:00 P.M. at our studio. I think that's pretty rare.

Look at how Peleg balances the professional and the personal:

At the beginning of every year I write down goals and accomplishments for the coming year. That list is what I turn to when things get blurry. It's a good focusing point. I also make a weekly accomplishments list every Sunday night that helps me plan out my weeks and prioritize the things that need to get done.

What about dealing with the client's expectations?

Our clients always know how we work. We make sure they do. At the beginning of each project, we have them sign an agreement that includes our process and terms. When the client gets to the point where we are compromising our integrity or their project is interfering with our daily workflow, we bring it out in the open right away and get the situation fixed.

At the beginning of each project we create a project schedule that outlines the important milestones and deadlines. Clients have to sign and agree to work within the schedule and if they do not, deadlines get pushed back and deliveries are not guaranteed and this seems to work well for us as the client is very clear of its responsibilities and allows us to budget in time for the creative work.

DEALING WITH STRESS ON PROJECTS

Most stress in a creative services business comes from trying to balance conflicting needs, especially on client projects. You need to be business-like and you want to be creative. You need to dedicate yourself to your work and you want to spend time with your family. Sound familiar? You could probably write an endless list of personal and professional stressful situations other than client projects. The important thing to accept is that this stress is normal. Distress, such as family illness or natural disasters, is not the norm and can't be managed like stress can be. If you have determined that you are dealing with stress and not distress, try these simple rules:

- **You'll never be caught up, so stop trying**. There will always be a never-ending succession of business and marketing tasks as well as your client projects to do (you hope!). Stop waiting for the in-basket to be empty. Stop anticipating feeling caught up with your work—both client and nonclient tasks.
- **You'll never make everyone happy**. There will always be client who will want you to feel or behave differently (especially with pricing). Stop expecting people around you to always approve of you or be happy with you. You can only do your very best to please your clients and run a profitable business. You can't control other people's feelings about you.
- **Worry is a great producer of stress**. Have pen and paper handy so that you can write down any particular worry. Put it aside to be considered later (this technique is also called "sleep on it"). Often, the worry has resolved itself or is no longer so overwhelming. So, get it off your chest. Motivational speaker and one of the authors of the wonderful *Chicken Soup for the Soul* series, Mark Victor Hansen, calls this type of stress "stewing without doing," and it is very nonproductive. Stop it!

- **Learn to say "no."** Often, stress is created when you say "yes," when all logic and common sense tells you to say "no." Pricing a creative services job is a perfect example. A client makes an assignment or pricing request and you know that an unqualified "yes" will cause great stress (and reduced profits). So try one of these three options, "No, *but* here's another *option* to look at" or "Yes, *and* this is what that change will *cost*" or, simply put, "Let me get back to you!" In each case, you have presented further considerations that will reduce the stress of dealing with difficult situations.
- **Finally, don't forget about using the concept of "hidden costs"** (chapter 7) **when managing project stress.** For example, when you tell a client "Yes, and this is what it will cost," remember that cost is not always money. On client projects, cost can be time, energy, attention, prestige, and esteem.

A Question of Balance

CASE STUDIES AND SUCCESS STORIES

David Veal says that prioritization has been his biggest ally in reducing his everyday stress:

> Let go of the importance placed on things. I have to meet my deadlines, but I do not have to say yes to every job. I have to work many evenings, but I let my body tell me when I'm not effective anymore and hit the pillow at that point. I put a value on work, but I also put a value on my child's school events, like participating in "Egg Drop Day." When I'm chained to the desk, [I listen to] music during creative time and spiritual books on tape during brainless work. Last ditch efforts include forced smiling, great coffee, and sitting aerobics.

The crucial question of work/family balance is hard for David:

> This is the toughest as my wife, child, and extended family are all affected by the decisions I make. Honesty, open communication, and flexibility are the points I have found helpful here. It doesn't always work well to balance out family and business, however if you are open and willing to proactively look for opportunities to share time and warmth with your family, you are rewarded ten fold.

David sees the best client relationships as collaborative:

> I do not feel like I have to assert myself to be a part of the process. My job is to produce imagery that conveys the client's message. My job is to produce options that will inspire the client to think outside the box, as well as to produce options well within the box. How far I can go either way with this box is reflected in the honest and clear communications we have at the outset. Ultimately, I always intend to give the client what the client wants and leave experimentation to my private work.

Notice how David maintains his commitment to "private work" in the midst of all his business challenges. This is a key point for any

creative professional. How does David balance project deadlines with creative quality?

The answer to this question will differ on a case by case basis, in all but two respects: honest evaluation of the timeline and clear definitions of the project. In the first strategy meeting it is important to write down a timeline of when stages of development will be approved and by whom. It's important to suggest timetable problems as soon as you detect them. It's important to note when you will be working into the night or over weekends. It is important to consider when the creative of the job is scheduled and when the production of the job is scheduled.

If you feel like this, you could use some time and stress management tools. Illustration by David Veal.

Michael Fleishman, of MCF Illustration, says that finding the time for both promotion and creativity is the core question, solvable through quantum theory:

> If you're in the business of illustration or design, you are a citizen of two worlds (sounds like a bad sci-fi, made-for-TV movie), and you must make the time to actively produce and promote. If you aren't a concerned, involved citizen, those sister worlds of business and aesthetics will collide (the sci-fi movie continues).
>
> I operate under what I call the "Small Chunk Theory of Relativity." Business. Creativity. Promotion/Marketing. Studio-time. It's all relative. A job (especially a big job or a number of jobs that come in at the same time) can be overwhelming and intimidating if I look at the entire task as a whole. But if I break the task(s) down into small chunks, doing something, every day, any job becomes manageable. Hours invested are variable, so the buzz-words are "constant" and "consistent." You must be disciplined and focused, but I'd rather diligently practice these mindsets than keep hitting the panic button.

Exercise and diet are crucial for Michael, too:

> For me, one way is daily or regular exercise—I can feel the difference physically, mentally, emotionally. Of course, the challenge is staying with the program. I purchased that Sears Craftsman twenty-seven-hour-day tool, but apparently it's on back order. Two things help here: (1) get off your ass and just do it and (2) be kind; don't beat yourself up when it doesn't happen. Think about it: these are not contradictory statements. When used as part of a complete breakfast, it really works.
>
> Also, taking time to relax, or just goof off, to have fun is very important. Hey, maintain your sense of humor at all times. Get away from the studio. Shopping, talking, and networking is good; getting away from the shoptalk is also good. Stay in the loop with your friends and family, obviously. I think you must also keep the following old (but accurate) chestnuts in mind when pondering

the considerable tensions of freelancing: grace under pressure . . . flexibility . . . rolling with the punches . . . shooting from the hip . . . adaptability . . . creativity . . . thinking on your feet. I could go on, but you get the picture.

Balancing personal and professional life is also a key question for Michael:

In terms of your business, I believe equilibrium comes from knowing yourself: what are you getting out of all this? Why are you doing it? What do you really like to do? What kind of design or illustration makes you happy? You shouldn't be going into business for yourself if you are motivated entirely by ego—don't do it if you're after fame, fortune, or respect. And, last but not least, don't do it out of anger. You should not go into business for "revenge"(for instance: getting back at the world because you lost your job to corporate downsizing). I think you should embrace self-employment because it fits you—spiritually, financially, conceptually. Question your motives and answer honestly.

If you say, "Personal life, what personal life?" it is definitely time to rethink being in business. "Success" and "quality" are relative, somewhat nebulous terms. In the long run, I want to be a "successful" person more than I want to be a "successful" illustrator. I want to be a "great" dad more than I want to be a "great" designer. I want to be a "good" husband and life partner more than I want to be a "good" businessman. There are trade-offs you make—with consequences—and it's not an easy juggle. Understand. Prepare. Be prepared. Really know why you do what you do; live with the results or make it better and/or different.

Remember that assertiveness begins with saying "no." Michael Fleishman again:

Questions of ethics, morals, and legalities are no-brainers. At these junctures, "no" becomes the biggest word in your vocabulary. Beyond that, often times you must say "no" to get to "yes." Often

times it's better to say "no" and walk away. Often times it's wise to hear "no" and walk away. And, of course, you can just say "yes." How to determine what to do and when? Well, this is kind of a fill in the blank test. I ask myself: What's the worst that can happen if I do _____ or say _____ or ask _____ or request _____ or demand _____ or question _____? I ask myself: What's the saving grace here? (At the beginning of contract negotiations, the question would be: What's the saving grace of this agreement?) Is there a comfortable personal and/or professional trade-off for doing _____ or accepting _____? Can I live with _____?

Think past your answer to the results or ramifications of that answer and respond accordingly.

Here, Gunnar Swanson, of Gunnar Swanson Design Office, delineates the way he reduces his stress:

Going on a bike ride. Walking down to the beach. Leading the sort of life I want. Doing the sort of work I want with the sort of people I want to work with. All of those require being willing to make less money than you might otherwise. Punching the heavy bag sometimes helps. I suspect that punching people wouldn't, even though the thought is sometimes appealing. I spend too much of my life reading and writing to various e-mail lists. It makes me feel connected but it can become a serious addiction if you let it.

Since Gunnar works out of his home, work/family balance issues are even more poignant:

My studio is in my house. That makes balancing much harder for some people—there's a tendency to work all of the time or get distracted from work all of the time—but it's good for me to be able to see my wife by walking across the house, take a bike ride at three in the afternoon, knowing that nobody cares that I was working at three in the morning and nobody cares about now as long as I'm in touch and make deadlines.

Don't give into the urge to say what you think people want to hear: "This will be done tomorrow afternoon." Leave time in schedules. Make it explicit that when client approvals delay the project that doesn't mean that you must make up the difference. Take time to think about the job schedule before committing to deadlines. Give yourself plenty of time to let things stew after the communication goals are set. And if you need more time, call up and say "I can deliver good work on time but I think I'm on to something and this will be much better if I delay things by another day."

Keeping Clients Coming Back for More

Once you have a chance at the first job, there is a tendency to rush through the standard business practices. Don't do it, especially with new clients. Creative people often feel if they are "easy" on the client on the first job, the client will decide to stay and not give the next job to someone else. No, it's not true, so don't lose your head! The way you handle healthy and profitable relationship with clients (that will turn this first job into a client who will come back again) is to stay cool and start with good business practices. Here are some project issues that will come up with the first job, and will need to be handled well to develop and maintain a strong relationship, encouraging clients to keep coming back with more work.

THE DEADLINE

This is a very delicate subject in any "first time" job with a design or illustration client. Many creative professionals feel if they meet an impossible deadline, the client will come back. Unfortunately, all that will do is ensure the client will always give jobs with not enough time to get them done properly in the future!

Every client has a late job horror story to tell and that makes him wary of giving accurate information on this point. The best bet is to ask the kind of questions designed to help the new client feel more comfortable with your ability to meet deadlines. Don't ask, "When do

you want this job done?" This is much too subjective a question to ask. Ask for more objective and measurable information such as, "When will the annual report be mailed?" "When is this new product launch scheduled?" "How many people need to approve this and how long will they need?" Look behind the deadline. By breaking the delivery into a series of benchmarks on a timeline, both you and your client will feel more in control of the process (and they will feel safer coming back for more).

THE SPECIFIC NEED
Be sure to find out what specific problem this design project is supposed to solve. The more accurate a statement from the client of the design goals and objective, the better opportunity you have to meet it. Meeting the client's goal, whether it is for a traffic-building Web site or sales-building package illustration, will always give you a better chance that they will come back again.

Eda Warren, of Desktop Publishing Services, Inc., Chicago, says that repeat business is all about a flexible relationship and a commitment to mutual learning of the client's problems and possible solutions:

> "Flexible" means being able to bend to all the craziness those clients can hand you, including changes past the last minute, unwarranted requests, and anxieties. And of course, they sometimes need handholding. To the extent that you can indulge them, without doing yourself a disservice, you can promote a relationship where they feel that you're on their side—and that's exactly the bond that cements a business relationship. I also feel that serving an educational role, which is natural to me as a trainer and designer, is important to the design development and supports my client relationships. I pass on my insights into their design problems related to our projects, their printer, costs, outputting files— whatever I can add to their understanding makes me feel I am providing a unique service. And of course the most important kernel is communicating the design strategies I have used to develop my solutions for their jobs. They feel they are getting more

value and are also more sympathetic to my work since I explain how their input directly affects the solutions I am presenting. That's responsiveness they can see and appreciate.

Many designers have difficulty explaining their design strategies because they are working on an intuitive level. Without that conscious intent, they are left with the power politics of personal preference and taste where the client usually "wins," but not necessarily to their benefit. In the graphic design class I teach for Dynamic Graphics, I emphasize the importance of language to the growth of the visual designer—articulating their choices at every point in the design process, while making decisions using the strategies of the design problem. There is terrific power in dealing with clients when you can speak to *why* you made the choices you did. You can engage them in discussion about mutual problem solving, not as the adversary across the table.

Eda cites her own personal learning, too:

As I get more mature as an individual and as a designer, I am better able to be sensitive to the needs of my clients, instead of focusing on my own needs. This is a big shift that has been taking years to accomplish. The opening that this change affords allows me actually see what is out there to be seen—the positive feedback, the client's sensitivities and dissatisfactions, whatever there is to pick up and respond to! Responding might involve talking to the client, deciding to be more accepting and generous or might just be increased awareness to bring to the next situation that is similar. I feel that the potential for growth and learning is limitless.

THE APPROVALS

The approval is another touchy subject between any new client and a creative professional. Sometimes, both are caught in nightmarish scenarios where everyone responsible loves the ideas and then someone with a higher authority shoots it down. Not only does this make your client look bad, but it could lose you the client! Do the most you can to protect yourself and your client—be a team. Find out how many

people need to approve the project. Who are they? How do they relate to this project? Where are they? How many electronic file transfers versus overnight deliveries are involved? Will there be personal consultations with you or will your client make the presentations for you?

Be sure to distinguish between subjective and objective approvals. Subjective is someone's opinion, i.e., how does the client like the color background selected? You could say that subjective approvals represent the aesthetics and a "matter of taste." Note how different this is from an objective approval, which is a measurable determination of accuracy—is this the correct color background? Is this the correct copy the client provided? Is the product in the illustration the correct size? You want to maximize the objective approvals and minimize the subjective approvals to get the job done and make the client happy.

Cathie Bleck, of Cathie Bleck Illustration (*www.cathiebleck.com*), gives five "core values" as keys to repeat business: "Reliability, Intelligent solutions, Originality, Quality assurance, and Treating them with respect." Cathie likes to get to know her clients "on a personal level, and strive to keep an open and honest dialog between us":

> "Keeping it friendly," so to speak, allows them the ability to feel that I am approachable on the project or any future projects, even if I don't get the job. I usually try to ask them in the bidding process, "Who am I bidding against and what factors might determine the decision?" We may start a dialog from there or another question regarding what I might be able to offer them that might make my service unique to the project.

Donald H. Sparkman, Jr., president of Sparkman + Associates, Inc., says clients want to feel that you are "their" special designer, even if they are using other designers:

> It's weird but true. That means never talking about other work you have in your studio that's in front of their work. Never mention other clients who are in line ahead of them, especially their "friendly" competitors.

He keeps his clients coming back by constantly getting their feedback on his work:

> Clients are usually verbal, if invited to be, and you need to invite their comments. This is like the owner of a restaurant asking you as a diner if everything is all right. It's in the owner's best interest as well as yours, for you to be honest. The same is true in reverse. So I always ask my clients how they feel their projects are proceeding.

Jessica Hoffman, senior art producer for Crispin Porter + Bogusky, offers this advice to freelancers wanting repeat business:

> Be polite, considerate, and mindful we are your potential client. Those flaunting an arrogant demeanor are filed as swiftly as possible—directly into the trash can. There is an incredible number of talented people in the world who are nice and fun to work with. Share your accomplishments—if you've won an award, were featured in an article, or even published for the very first time, that's a great reason to send out notice! By doing this, you introduce yourself or remind me of who you are in a more significant way.
>
> Self promotion—Do direct mail, e-mail, Web site, portfolios. Don't call every Friday and ask when we are ever going to give you a job. For some reason, this tactic has proven unsuccessful. Do be patient. You may be an incredible freelancer—but just not meshing with whatever we are doing at the moment. You may someday in the future!
>
> Do offer to shoot comps with the companies whose clients are in line with the subject matter you wish to pursue. Be honest about what you can offer. You may end up creating a great relationship while expanding your ability! Start by exploring a lot before representing you can actually do the work and then do it well, test, and then pitch. Research your clients. If you want to do commercial work, step into editorial congruent to your new direction. Editorial work may not necessarily equate to financial gain, but the experience and exposure could potentially pay off ten fold. This far out-

weighs all else because you are advancing and progressing with your craft, pressing forward and stretching yourself. A nice benefit is another opportunity for name recognition through credits!

HANDLING CONFLICT

Finally, your skill in handling conflicts with clients will determine whether your relationship will prosper or end. It is important to know that conflict is not bad. In fact, it is natural and inevitable and we cannot avoid it. What matters is how we choose to manage the conflicts that will arise, and maintain a relationship characterized by integrity and open communication to achieve the "win-win" that keeps clients loyal.

Today's competitive marketplace justifies a closer look at how creative professionals look at their relationships with clients. It's also important for the designer to understand how the client sees his relationships with creative professionals. The more you learn and study the relationship between the creative and the client, the better chance you have of getting the job, and then turning that job into a client and a long-term relationship!

Concerning the inevitable conflict situations with clients, Cathie Bleck says:

I have very few conflicts with clients, but when I do I try to be direct without being negative. Pointing a finger at the problem and not them will hopefully preserve the relationship for the future. Putting the agreement in writing from the beginning of the project serves to alleviate most communication problems.

Don Sparkman on client conflict:

Given that 99 percent of the conflicts are over money, I think you have to leave a long paper trail with every client. If the client isn't expecting certain items on an invoice (and that's the most common conflict) then you haven't done your job in keeping that person informed. I love e-mail because you can send a client a note

like "How's your new car, and by the way, your project's change-orders will mean an extra $500 on the final bill. But geez, that's one sharp car."

Eda Warren offers the following advice for handling client conflict:

This is a challenging question! Here are a variety of thoughts that I think are all true. I am a big one for admitting when and where I am wrong. I make mistakes from time to time; even if it's not exactly a mistake, I might still recognize that I could have handled a situation more constructively. In other words, although a problem is rarely one-sided, I always look at a conflict situation to see what I could have done better or different that would have promoted a more positive result, rather than focusing on what the client did or did not do. Then I always communicate to the client what I feel is my share of responsibility for what has evolved/happened. I feel that taking this approach is the honest thing to do and, to some extent, it often disarms defensive thinking that gets you nowhere. [It] opens up the possibility for genuine discourse and hopefully an agreeable resolution to the conflict.

Another component is recognizing what you can live with and what you can't. The more that you can forgive and let go is beneficial, without compromising your own integrity. Recognizing how you feel is something you usually know intuitively—whether the situation requires that you speak up or not. Of course, repeated difficult behavior from a client should not be accepted. Gently letting the client know how her actions put you in a difficult or untenable position is of course something that we all must do from time to time and hope that we will not risk losing the client. But in fact, at this point, you must accept that losing the client is a risk and be willing to allow that to happen. It may not be the worst thing in the world and it takes being willing to let go of the client in order to save the situation. Without that awareness, you have no power in the relationship and nothing good can come of that.

Why Networking Works

One of the most important skills of the successful business owner is networking. Even in the design and illustration business, people will hire people they know! Networking among associations is not selling or any kind of hard-sell promotion. It is simply the connections and relationships that develop on a personal level, outside traditional and direct tactics like portfolio presentations, mailings, and advertising. The best marketing plan is to layer your direct marketing efforts with the softer sell of networking for maximum effectiveness. In addition to being more effective, you'll also increase your marketing equity, that is, each promotion effort will be worth more than what you paid when it has the support of the complementary efforts of association marketing.

NETWORKING DOMAINS

There are three types of associations to identify and network with: client, community, and peer. Your best reference for identifying different client industry associations is the "EA Directory," or Encyclopedia of Associations, published by the Gale Group (*www.galegroup.com*), available in the Business Reference Section of your local library.

Community associations are readily identified by your local chamber of commerce—or even the phone book. Then, you have your national design, illustration, and graphics industry associations.

For most of the benefits, you must be a member of the association. Of course, association dues are not only tax deductible but also should be considered as essential an expense as paying for promotional material. As you read each section below, cross-reference to your current marketing plan and analyze what items can be put to work immediately!

INDUSTRY ASSOCIATIONS

There are six ways to incorporate associations of your potential clients into your marketing strategy:

1. **Look for associations of potential clients that produce newsletters for distribution to their members.** These can be excellent avenues for both advertising and publicity. The ads you buy can be anything from business-card size to full page. Because the circulation is reasonably small compared to many of your other advertising opportunities, your ad rates will be low. Don't be misled by the small circulation! Even if there is only a circulation of three hundred, each is a targeted client for your design and illustration. This is much more effective than a "shotgun" mailing to thirty thousand people in order to find the three hundred qualified clients! If you are concerned about production values that are not high enough (due to the smaller ad rates and production budgets), ask for their freestanding insert or ad insertion rate. This will allow you to print your own ad and have the association insert it before mailing to members.

2. **Look for associations of potential clients that produce directories of their members.** This will provide you with a source of leads for making portfolio presentations and looking for assignments. In addition, your (probably free) listing in the directory is a supplementary advertising tool

to the perfect captive audience. Imagine being among a small, select group of businesses listed under "design and illustration" in the resource section of your client's association membership directory!

3. **Look for associations that offer their membership database on a CD-ROM or floppy disk,** to save time keyboarding the names and addresses into your computer. If they can share electronically, you have your labels for your next direct mail campaign.

4. **Look for associations of potential clients that have awards programs and active committees you can join and get involved with.** For example, the hospitality committee is an excellent choice. There's no easier networking than being the official greeter at a meeting. Volunteer for different committees and positions, join the board, and try to work with as many people as you can. Ultimately, this is the best way to get the experience working with potential clients, experience you often need to get paying jobs with them.

The quality of the clients you'll find when you market to associations is a major advantage for a couple of reasons: 1) companies that take the time and money to participate in their own industry associations tend to be more aggressive about their marketing and promotion. In other words, they are more likely to use your design and illustration than companies that stay home and keep to themselves. 2) Every association has recognized business practices and ethics. Clients that have their own business practice ethics and standards are more likely to recognize yours!

And finally, keep in mind that although your association client contacts may not always have the work you want to do more of, they can be very good for the "bread and butter" work every studio needs to pay the rent.

COMMUNITY ASSOCIATIONS

It is specific and maybe unique to the marketing for a creative professional that you must show the work to get the work. This is easily done by donating services to nonprofit groups for the specific purpose of having a client project for your portfolio and promotion. It is a win for the nonprofit that gets very cool stuff done for free and a win for the creative person that gets a "real" job to show. The networking brings you face-to-face with these charities so you can be selected for the pro bono work.

Groups that serve communities range from national associations, such as Project Cuddle, to your local humane society. There are two benefits added to your marketing strategy that come from networking with a charitable, community association: centers of influence and public service projects.

Centers of Influence

Centers of influence are people in the community who are the movers and shakers. People you are not likely to run into and have lunch with on a whim! Though they may not directly buy design and illustration, they influence people that buy your services. Their relationship with you is an endorsement that could be a valuable marketing asset. Sometimes a local service club, such as Rotary International or Kiwanis club, affords a great opportunity to meet informally with such people. And they often sponsor local or regional events that will help you build on these business relationships.

Public Service Projects

Probably the best networking marketing benefit is your participation in public service projects in the community. They often bring together some of the community's best creative people. This is usually because, though these charity groups may not have large marketing budgets, they do give "free rein" on a lot of the design and illustration. In addition, they sometimes do get high-level production values by adding a printer or paper company to the all-volunteer creative team.

Most of all, you get all the benefits of a "real" job: client reference, testimonial, publicity, printed pieces—even the chance to work with potential clients!

PEER ASSOCIATIONS

Marketing yourself through a group of your peers is the most neglected and overlooked tool of network marketing. Joining and participating in your peer association should be considered a requirement of business and not an option. Here are some of the benefits from joining or renewing your dues with your design and illustration association:

- **Professionalism**. First of all, you can't really be a professional in today's marketplace without being able to show yourself as one. The quickest and easiest way for any client to evaluate you are your memberships in professional associations or affiliations. They speak for themselves! So don't leave home without one.
- **Information**. As a member, you will get more information from being connected than being the traditional loner or nonjoiner.
- **Referrals**. Often, fellow members refer assignments to you. When they can't or won't take the job, you are their "backup" and get the job referred to you!
- **People Skills**. Finally, network marketing gives you the opportunity to practice all the skills you are learning—or learned and forget to use—that come with running a business. If you want to learn publicity and introduce yourself to the local and national industry media, join the publicity committee. Want to overcome your reluctance to call total strangers and get them to give you work? Then, join the membership committee.

Peer association membership gives you the safe place to practice these skills, which you can't usually do in school or with your clients.

EXPERIENCES WITH PROFESSIONAL ASSOCIATIONS

David Veal, of The I Spot (*www.theispot.com/artist/dveal*), offered the following observations about the value of association involvement:

> In the 1980s, I was just out of college and bought the Guild's *Pricing and Ethical Guidelines Handbook*. I was hooked by the relevant content. It just happened that there was a Colorado chapter to join and do volunteer work for, Colorado Alliance of Illustrators. In the 1990s, I helped to create this local illustration organization to promote illustration to local art buyers and to present industry concerns and business practices through educational programs. I joined the Art Directors [of Denver] in the 1990s for networking purposes. [Also] a chapter of AIGA opened up in Colorado recently and I felt it was important to network with, and learn from, the design community, both locally and nationally. Primarily I have benefited from business programs. They inspire me to try new administrative and marketing methods. Secondly, the networking is great for marketing and building a nest of friendships.
>
> The main reason for joining is to elevate your reputation. When you join a board or committee you are giving back to the industry while enhancing your market exposure and networking capabilities. Truth be told, once you get into the swing of active membership it becomes its own reward. It is addictive, inspiring, educational, and a lot of fun.

When is Advertising the Right Tool?

Now that you have a marketing message and a target market (chapter 1), all your self-promotion materials need to be directed toward the work you want to do more of (not necessarily the work you are doing now)! This includes any advertising you do for your design or illustration business.

In advertising, look forward, do not look backward. Always look at advertising the work you want to do, not just what you do. As an example of a marketing message and a target market to advertise, let's say you have decided on packaging design. Then, your advertising will focus on a packaging design message, in text and graphics. Instead, if your message is your illustration style, all your advertising will focus on your personal style and the way you work and conceive of designs. This alignment is crucial. Your target market comes first; it lends focus and direction to your marketing message. All advertising must then flow from your strategic marketing message.

Remember, marketing is made of many different tools and advertising may not be the right tool for you. Your portfolio, promo pieces, and even your direct mail and e-mail marketing will probably be your primary promotional materials. Since advertising is one of the most expensive and least measurable tools, you will have to be sure you have matched your marketing message to your media.

STYLE-BASED MARKETING MESSAGE

First, if your marketing message is based on your style, you will be more likely to consider buying display ad space. Many illustrators use a "style" marketing message, so it would make more sense to use display advertising for illustration than for design. Style is not the type of market easily researched and you cannot always second-guess a client's need for style. When you have a strong style, you will want to broadcast your marketing message to the tens of thousands of potential clients larger circulation ads can reach. Then, they figure out that you are perfect for their project and they will call you.

INDUSTRY-BASED MARKETING MESSAGE

Second, if your marketing message is based on a specific industry, you will be able to check on buying ad space in industry trade publications—even in industry association newsletters. Though these are smaller circulations (and carry less expensive ads), they are highly targeted to the audience you are trying to reach for your design or illustration services.

USE-OF-WORK OR SUBJECT-OF-WORK MARKETING MESSAGE

Third, as a designer or illustrator you may be less likely to invest in display advertising for a marketing message based on the use of your work or the subject of the work. Each of these two markets has a client base that you can either research or buy a list for, and then use direct mail marketing.

Because your clients will give you other kinds of projects they want done, be aware that you do not need to change your marketing message (and ad campaign) when you get work you are not showing in your ad. Stick to your ad campaign. For example, your best packaging design or illustration client decides it is time to include you in their annual report project. This does not mean you need to change all your advertising over to annual reports. Simply do a great job, take the money, and say "thank you." Most important to note: you do not have to advertise for all the work you get, just the work you want to

do. Another example: You are promoting your strong, visual style as a designer or an illustrator and then get a job that doesn't quite tap into your highest level of technical ability and creativity. No problem, simply place that sample in your file of promotional materials just in case this type of project ever does come up again!

ADVERTISING YOUR CREATIVE SERVICES

Usually, advertising is defined as planning and buying ad space and filling it with your marketing message and a "call to action." It could be a business-card-size ad or a two-page spread. However, there are two distinct advertising tools you can use in design and illustration—free listings and display advertising—and we will study each of them in this chapter.

While we are talking about planning, be sure to plan a budget for your overall marketing effort—including any ad campaigns. Good advertising budgeting standards call for an average of 10 percent of projected gross sales to be set aside each year for all the different marketing tools and techniques. Use projected sales (how much you want to sell) rather than last year's sales. This way you will be marketing for the future, not the past! Projected sales amount calculates this way: if you plan to make $100,000 gross sales, you'll spend an average of $10,000 to do it.

SUBMITTING FREE LISTINGS

Start with getting all the free listings available to you as a creative professional. Some are print directories with Web sites, some are stand-alone Web sites. Your design and illustration peer association membership is the first free listing to look for. Even though it may just be on the association's Web site, it says, "You are a professional." Association Web sites often use pull down menus so clients can search for different types of design or illustration. Also, every industry trade association has reference books, and many of these offer free or low-cost information listings. Many of the creative sourcebooks that also carry display ad space offer listings in both their online and print directories.

True, it is just a listing (no pictures) but many text-only free listings include a "specialty line" where you get to very briefly describe your marketing message. Remember, advertising like this is for what you want to do, not what you do! For a listing of creative sourcebooks, check the Workbook Directory (*www.workbook.com*) and on the home page, click on "directories." From there use the pull down menu and select "directories." There are at least forty selections and many offer print and online listings. Another resource is *www.creativepro.com*; click on "directories" on the home page toolbar and then click on "creative associations."

PLANNING DISPLAY ADVERTISING

The objective of advertising design or illustration services is not to sell, but to stimulate a response to bring a prospective client to you. In responding, the prospective client then becomes qualified for the process of selling. There are two approaches to planning your ad campaign. One, you want to keep your name recognition at the very high level you have established ("image advertising"). Two, you want to sift through all the potential clients who'll see your ad and reach the ones interested in working with you ("response advertising"). "Image advertising" is most often used for larger, more established organizations.

Since you'll need to do response advertising, you should plan your display ad with two objectives:

1. Communicate your marketing message
2. Ask for a response ("call to action")

Different marketing messages will then need different ad campaigns. It is very important that you start with that same client profile from your direct marketing plan. Find out who your clients are and what they read. Where will they see your ad? How big a circulation do you need? Remember: don't overlook the smaller circulation publications such as industry trade association newsletters! Once you have a list of all the publications your targeted clients read, then call

and get their media kits to determine and compare rates. You don't have to do full page ads in full color. Be creative, be flexible; for response advertising, a quarter-page ad in a trade association magazine may be more effective than a two-page ad in a crowded and busy creative directory!

DESIGNING YOUR ADVERTISING CAMPAIGN

Once you have decided that a response ad campaign is appropriate, sit down with an art director and copywriter and form a creative team to add the objectivity you may lack designing ads yourself. Review the bullet points below for factors to include that will increase the response to your ad campaign:

- **Decide on the response goal, aligned with your marketing message**. Unless you have a well-established name and marketing message to maintain with an "image" ad, be sure to design your ad for soliciting a response in addition to aligning and reinforcing your marketing message. After all, if you don't, then you are just showing pretty pictures. Clients will do what they are told—not much more and not much less. This media is impersonal. You are not there when they see your ad, so it has to work ten times harder than a portfolio presentation.
- **Make the response mechanisms (how the client can reach you) attractive and easy to use**. When you create an ad that compels clients to inquire, decide on your risk/response ratio. A "high-risk" ad will get lower response. A "low-risk" ad will get more response. "High-risk" ads effectively discourage responses from people who are not in your target market. They act as screening devices. An example of a high-risk ad would be one saying, "Call us for your next project." Big risk for the clients; they do not know you yet and it is hard to make the leap from your ad to working with you on that first job. An example

of a low-risk ad would be one saying, "E-mail us to receive more information about our services." Less risk here for the client. High-risk and low-risk ads both work: you are simply deciding whether you want to filter a large pool of potential clients down to the few interested ones (high-risk/lower response), or get every client even remotely interested in your work (lower-risk/ higher response).

- **Determine what makes you or your work special, and include that in the ad campaign design**. It could be a style, philosophy, personal background, cultural awareness, the location of your studio, or even the ad concept itself. Clients hire designers and illustrators for how they think— so show them!

- **Plan a campaign with enough frequency**. Sad but true: your ad will need anywhere from six to sixteen contacts with your clients before they will recognize or resonate with your message. Repetition builds recognition, and recognition builds response.

- **Add credibility to the ad design with client testimonials, quotes, job references, or peer group association memberships**. Credibility is not naturally part of any ad design; you have to add it. We have become fairly jaded about claims made in ads. All any client knows for sure about you is that you found some money to buy an ad, unless you convey a more complete message about your proven capabilities.

- **Include a sense of yourself and what you might be like to work with**. *Ads are an impersonal medium* of self-promotion and need to be warmed up with a personal identity clients can relate to. Illustrators often use a self-portrait that visually repeats the marketing message and would be perfect to include in an advertising campaign design. Designers often use personal philosophy or design objectives to set themselves apart. Ask yourself, what personal

information can you include to help the client make the decision to respond to your ad?

- **Always think in terms of a coordinated, aligned campaign, not just an ad here or there**. Advertising is a long-term commitment towards building an image in the minds of your potential clients, even when the most immediate objective is evoking a response.

ADVERTISING IMAGE SELECTION CRITERIA

A crucial part of any ad campaign is the selection of visuals and images used to communicate your marketing message. Here are some tips to review with your creative team:

- **Which category of marketing messages does your ad campaign communicate? Tailor your visuals to your marketing message**. Again, there are four: a particular style of work, a specific industry, the use of the work, or the subject (see chapter 1). A subject-specific marketing message such as, "Call on us for your architectural illustration needs" will define the visuals clearly to you and the viewer of the ad. Remember, you are advertising for the work you want to do more of (i.e., architectural illustration), not the work you are willing to do (just about everything).
- **Show the everyday subject in an extraordinary way in order to stimulate the client to call and inquire**. This is an important tactic in general, but it is absolutely crucial for a "subject" marketing message. For example, take any given subject—food, people, architecture. You need to illustrate the most creative and technically challenging visuals for your ad. It is the same with design, and true for all four of the marketing messages. Your objective is to get your client to stop turning the pages of the publication or sourcebook and study your visuals, read your ad copy, and decide on their response. You want to create visuals for your ads that prompt clients to ask themselves, "How did they do that? I need to know!"

- **Work with the most incredible creative team you can put together and don't forget the advertising copywriter.** Be sure to adapt, but not adopt, when looking at other creative professionals ad concepts. Don't copy! Be creative about how you and your team design and carry out your ad campaign.

Because print advertising is an impersonal medium, you will discover there is often a gap between what you show in your ad and what type of work the client is looking for or what you get asked to do. The paradox is that, very often, your ad will move and inspire a client to call even when they do not have exactly the type of work you show in your ad. They simply want to work with a creative professional who can do that level of work. Of course, this testifies to the power of the image as used in advertising. Hopefully, the client will have a future need that relates more closely to your marketing message, but at least for now you have the start of a client relationship.

Cathie Bleck's ads in Showcase are consistent in design and style. As ad reprints, they work together perfectly when packaged as a mini-portfolio (see this page and the following two pages).

Public Relations Strategy

A public relations strategy is a three-step campaign: submission of information about your work to the media, getting it accepted, and then getting it published. Publicity is probably the most over-looked area of marketing design and illustration, yet for a little effort it yields an enormous return on your investment. Publicity can be an impersonal promotion tool (like direct mail and advertising), but the goal of publicity is not to sell. The goal of public relations is to build recognition. Unlike other forms of impersonal promotion, you can't buy it. In fact, it does not cost you anything but a stamp or an e-mail to submit your press releases.

On the plus side, getting published gives you instant credibility. In addition to credibility, reprints of any publicity make wonderful promo pieces. And, of course, getting published builds "word of mouth." On the downside, you can't buy the space or be guaranteed publication. So you will lose the direct control you have with an advertisement but gain the credibility of the publicity. The protocol is to submit, get accepted, and then get published.

PUBLICITY MEDIA MAILING LIST

Identify the media you will be submitting press releases to and build a media database for a mailing list. Unlike advertising, where you would only buy space where clients can see your ad, you will submit

your publicity as widely and broadly as possible. (Remember you are in this for the reprints to use as additional promo pieces!) Research magazines, newspapers, and newsletters of the all three major media groups: the clients, your peers (other designers and illustrators), and your community.

ENTER COMPETITIONS FOR CREATIVE AWARDS

Research all the client, trade, and design industry publications that hold annual creative awards. You get the immediate exposure upon entering when, quite often, your potential clients are the jurors. When you win, you get publication exposure. Then, you get to write your own press release, further expanding on the equity you are earning from the (usually quite modest) entry fee.

GET INTERVIEWED

This is more important for creative professionals when you have been in business a while or you are changing your career direction. Research and submit your work to book publishers to be included in their compilations and textbooks. Check on all publishers in the graphics arts field for books and magazines for designers and illustrators. Contact the authors with an interesting story pitch to try and get interviewed. The Web site of the publisher usually has a "contact our authors" section. Get your work published in a book or a magazine, and you have an additional item to generate a press release with.

DO SOMETHING NEWSWORTHY

Plan upon having a newsworthy item to submit to the media at least quarterly. You can always generate press releases outside this timeline, but at least it will be on your marketing calendar to do quarterly. Don't worry about not knowing at this moment what will be newsworthy three months from now; something will always come up. Here is a list of newsworthy things that you will do in your business:

- Open or relocate your business
- Add (even part time) any staff or a rep

- Improve your business with a new or expanded service
- Show in a juried show or exhibit
- Win an award
- Complete an interesting project
- Get published in a book or magazine
- Be elected to any association board or committee
- Work on any public service (pro bono) projects

The last item is particularly significant. If you've joined a service club, for example, they often organize community efforts requiring the support of designers and illustrators. Also, local arts organizations that are nonprofits often need design work done "at cost," which can attract favorable public awareness.

Cathie Bleck's "February" calendar illustration with extra tear sheets given to clients for framing (see this page and the following page).

Eda Warren did a brochure series for a music ensemble in Chicago to promote their chamber music seasons.

PRESS RELEASES: HOW TO GET THE NEWS OUT

Always use a standard format press release to submit your news to the media. Because editors receive hundreds of press releases a week, be sure you conform to the standard format to avoid having your release thrown away. This is not a personal letter to the editor. And whether you submit your press release in print or online, all the publications get the same standard press release from you.

First, some tips and hints to keep in mind about press releases:

- Find out from the publication's Web site whether it prefers mail or e-mail press releases.
- Enclose samples or photos whenever possible to increase the media's interest and your chances of being published.
- Be sure to send the release on letterhead—it looks more professional.
- Press releases are written in the *third person present tense*, so the editor does not have to rewrite your submission to accept your news as worthy of publication. Write it as though you were reading it in the magazine.
 — Wrong: "I won a national award."
 — Right: "Ellen Reidy wins a national award."
- An "inverse pyramid" style is used. This is a journalistic style has the most important item in the first line, followed by successively less important material. It allows an editor with limited space to reduce the article's size without destroying its content.
 — Quick test: would your release read well without its last sentence? If so, how about its second-to-the-last sentence, etc.? Remember the old saying, "There's no such thing as bad publicity." Getting your name published in a shortened article is better than not getting it in at all.
- The "###" at the bottom of the press release indicates "end of release," so the editor is not looking for a second page.
- Brevity is always welcome.

As you review these sample press releases, note the rigidly designed format. Because these are just samples, they are shown single space. Be sure your actual press release is double-spaced. The text in parentheses indicates information you will fill in to complete your actual press release.

New Location Press Release

For Immediate Release: For Information Contact: _____
(Today's date) _____
(Your name and phone number) _____
(Headline) _____
(Your city) _____

. . . Maria Piscopo, owner of Creative Services Consultants, has relocated her business from (city) to (city). Piscopo provides photography, design, and illustration services and is starting her twenty-fifth year in business. Her clients include corporate communications departments, ad agencies, and design firms. Piscopo is a member of Society of Photographer and Artists Representatives, writes for national industry publications, teaches for Dynamic Graphics Training, and is the author of five books and four videos on marketing and management for creative professionals.

###

Interesting Project Press Releases

For Immediate Release: For Information Contact: _____

(Today's date) _____

(Your name and phone number) _____

(Headline) _____

(Your city) _____

. . . printQuick.com announced that it has signed a three-year technology license agreement with XYZ Computer Systems of Irvine, California, a subsidiary of ABC Inc., which is based in Houston, Texas.

Under the agreement, printQuick's print-from-the-Web technology will power portions of XYZ's Web-print activity site, (name Web site). The free site offers visitors the opportunity to print custom greeting cards and other projects direct from the Internet via desktop printers like the XYZ Series 7000 inkjet printer.

In addition to bringing a broader array of print projects to the XYZ site, and a smoother, friendlier user experience, printQuick technology will allow XYZ customers to import and manipulate their own personal photography into many of the activities.

The agreement also grants XYZ Company the limited rights to distribute printQuick's browser plug-in from within its printer drivers worldwide.

"The Internet as a print communication medium has been for the most part been completely overlooked," said printQuick.com CEO Drew Haygeman. "Today's desktop printers are capable of producing stunning, high-quality documents, but most consumers do not use them for much more than printing letters. It takes a visionary company like XYZ to recognize, and then act upon, an important, emerging trend. We at printQuick.com are proud to be a part of XYZ's vision."

Founded in 1999, printQuick.com, Inc. is a spin-off of HIJK, Ltd., based in Carlsbad, California. HIJK is a full-service design and marketing firm that has provided solutions to companies such as American Honda Motor Company, Inc., Hewlett-Packard Company, and Kyocera Wireless Corp. for nearly twenty-five years. HIJK's proven design expertise, combined with real-world knowledge, adds depth and breadth to printQuick.com and its offerings, uniquely combining the powerful persuasion of print materials with the immediacy of the Internet.

###

Relocation Release

For Immediate Release: For Information Contact: _____

(Today's date) _____

(Your name and phone number) _____

(Headline) _____

(Your city) _____

. . . Designer/illustrator Darlene McElroy has relocated her studio to 1600 Birch Street, Newport Beach, California. McElroy has just returned from a sixteen-month world tour visiting the countries of Indonesia (specifically the island of Java) Thailand, Morocco, and Greece. In her travels, she met and worked with other artists in France and Italy. As an illustrator and designer, her clients have included AVCO Financial, Carnation, Kawasaki, and Carl Karcher Enterprises. Her artwork has been honored by the Society of Illustrators, the Public Relation Society of America, and the Orange County Ad Club.

McElroy's work with art students has brought her teaching positions at local colleges as well as publication in national industry magazines. McElroy feels her new "international" point of view will benefit both clients and students in the future.

###

Expansion of Services Press Releases

For Immediate Release: For Information Contact: _____

(Today's date) _____

(Your name and phone number) _____

(Headline) _____

(Your city) _____

. . . Ina Kramer's Art Director's Medical Survival Group is now available in Costa Mesa, California. The medical illustrators in the group, based from San Francisco to New York, will be represented by local art/photo rep Maria Piscopo. In the $500 million-plus medical advertising market, medical illustration for commercial clients is growing in popularity. Each of the group's illustrators has his or her own unique style, along with the medical training and background to do both the straight technical illustrations and the conceptual illustrations required by advertising clients.

Many of the group's artists are members of the Association of Medical Illustrators, and some are featured in the book *The Best in Medical Advertising and Graphics*, published by North Light Books. Group founder Ina Kramer is president of the Rx Club in New York. West coast rep Maria Piscopo has been working with medical advertising clients for twenty-five years.

###

For Immediate Release: For Information Contact: _____

(Today's date) _____

(Your name and phone number) _____

(Headline) _____

(Your city) _____

. . . John Smith, owner of XYZ Design, has just returned from teaching a six-week digital illustration and production course for Dynamic Graphics Training (*www.dgusa.com*) and has added services of multimedia and illustration services. Smith comments, "My clients need me to provide more assistance to them and take on more of the responsibility for image production. We're not just designers anymore." The expansion includes advanced computer and digital printing equipment and high-resolution image-enhancement software. Smith says this added capability is essential to business, "Clients don't think in terms of needing computer imaging, as much as they need visual solutions that are fast and cost-effective."

John Smith has been an illustrator and designer based in St. Louis, Missouri, for fifteen years and is past-vice president and current board member of the American Institute of Graphic Arts.

###

Won an Award Press Release

For Immediate Release: For Information Contact: _____

(Today's date) _____

(Your name and phone number) _____

(Headline) _____

(Your city) _____

. . . Maria Piscopo, Costa Mesa-based consultant, has been awarded the Grand Prize in *Medical Marketing & Media's* magazine article contest for her submission, "How to Buy Creative Services." The article discusses how to hire illustrators, artists, and designers more creatively and cost-effectively. It is based on her seminar for Dynamic Graphics Training (*www.dgusa.com*), "Managing Creative Services."

Publisher CPS Communications selected the winning article based on a topic of interest to its healthcare and medical marketing readers. The prize-winning article will be published in upcoming issue of the publication *Medical Marketing & Media,* and the grand prize is a trip for two to the Caribbean.

Piscopo is a creative services consultant and author, and a professional trainer. She is a member of Society of Photographer's and Artist's Reps and has been in business for twenty-five years.

###

Exhibit Opening Press Release

For Immediate Release: For Information Contact: _____

(Today's date) _____

(Your name and phone number) _____

(Headline) _____

(Your city) _____

. . . Mary Jones, Seattle-based designer, opens her first exhibit of fine art at the Newton Gallery on Saturday, July 11 from 7:00 P.M. to 10:00 P.M. This premiere exhibit, "In Your Dreams," will run from July 11 to August 29 at the 503 31st Street gallery in downtown Seattle. Jones says her passion and fine art style are based in her commercial design and illustration. Her first assignment in this style was for the cover of (insert magazine name). Educated at the Art Center College of Design in Pasadena, California, Jones specializes in design services for magazines and paper products publishing companies.

###

Elected to Office Press Release

For Immediate Release: For Information Contact: _____

(Today's date) _____

(Your name and phone number) _____

(Headline) _____

(Your city) _____

. . . Greg Smith, Atlanta-based owner of his own design firm, has been elected president of the local chapter of the Graphic Artists Guild. A member of the Graphic Artists Guild for ten years, Smith specializes in product, packaging, and catalog design. His current project is a series of new product designs for the next generation of Coca Cola products, to be launched in the year 2005.

###

THE EXPERTS REFLECT ON PUBLICITY

Greg Paul, of Brady & Paul Communications Inc. (*www.bradyandpaul. com*), now an experienced and successful designer, tells of his early experiences in getting publicity:

> When I was just starting out as an art director, I sent out press releases and accompanying visuals anytime I thought we had done something newsworthy at the magazine where I was working. My goal was to increase the magazine's visibility in the design community, so that when I called top photographers and illustrators with assignments they might be familiar with the quality design and art direction we were doing. It worked. The magazine began to be featured frequently in Art Direction and Graphic Design USA. When I would cold call some of the best image-makers, I was pleased to learn some of them had heard of us through the positive notices my press releases had garnered. It was a happy accident that the same PR campaign also boosted my own personal career.

Bud Willis, of Willis Advertising (*www.willisadv.com*), considers publicity to be an important part of his firm's overall marketing strategy, despite the unfavorable comparison it might get with the effectiveness of direct marketing strategies:

> The important thing is to keep your name in front of your target market in many ways and as frequently as possible. We send out news releases on a monthly basis to about five local newspapers and business journals to announce new clients that we have begun working with, major projects that we are working on, and awards that we have received during the previous month. We have been very fortunate in obtaining at least some mention, somewhere, almost every month. We also send out a monthly newsletter with the same information to all of our clients and prospects, as well as posting it on our web site, *www.willisadv.com*.

Lisa L. Cyr, of Cyr Studio (*www.cyrstudio.com*), offers down-to-earth advice about public relations:

Adopting an ongoing public relations component to your marketing mix can prove to be very effective in gaining exposure within a chosen market. Begin by introducing yourself or your firm to the trade publications and organizations through a thought-provoking media kit. To stay fresh, continue to send regular press releases and feature story ideas that highlight your uniqueness in the industry. As a writer, I love when creatives keep me in touch with what they are doing. It helps me in developing ideas for potential articles and books—making my job a lot easier.

On Entering Award Competitions

Greg Paul does not compete for awards as he used to, but still believes in the value of the pursuit:

I think [entering competitions] is an extremely valuable promotional tool, although we don't currently enter any of the competitions. There are a couple reasons I haven't entered any competitions in years, although we have picked up a few citations recently through submissions that were sent in by our clients. First, about the time I began getting invitations to act as a juror for various annual competitions, I stopped submitting to avoid any appearance of conflict of interest and to spare fellow jurors the awkward predicament of having to pass judgment on a fellow juror's work. Secondly, when we formed Brady & Paul Communications, my role changed from art director to visual communications guru. As outside communications consultants, my partner John Brady and I assume the roles of creative coach and editorial advisor rather than hands-on art director or editor. It is usually an in-house art director who ultimately executes the actual printed pages. We do recommend that the in-house art directors compete in any competitions that are a good fit for the kind of work they do. The prestige and visibility that the annuals provide acts as a magnet for gifted contributors and gives the publisher something to crow about to potential readers and advertisers.

Leslie Burns, of Burns Auto Parts artist representatives, offers a word of caution on awards and competitive showings "unless the work you are showing is reflective of the work you do commercially":

> If it is too different than the work you show in your portfolio, you are fragmenting your branding and that is negative. If it is what you have in your book, then it is a good thing. The important thing is to be consistent in what you are showing to potential and existing clients.

On Participating in Shows

Greg Paul on participating in shows or events:

> There is no better way to achieve national or even international visibility than placing your work regularly in the big design annuals. That's what really gave my career a jump-start. Without the exposure that *CA*, *Graphis*, *Print*'s Regional Design Annual, the Society of Publication Designers, the Art Directors Club, Society for News Design, American Illustration, AIGA, and the Society of Illustrators gave my work for *Ohio Magazine* and *The Plain Dealer* magazine (Cleveland), no one in the design community outside of Ohio would have ever seen it. When *Communication Arts* called about doing a feature on me and my work at *The Plain Dealer*, I asked how they had heard of us. The answer was that they were impressed with the submissions to the *CA* Annual they had received from us over the years. After the article ran, I would get calls from people around the country asking what it was I did to get into *CA*, hoping to be featured too. All I could tell them was, "Submit good work to the annuals. And don't call them— maybe they'll call you."
>
> A desperate eleventh-hour call from the City and Regional Magazine Association seeking someone to fill in for a speaker who canceled at the last minute led to a twenty-plus year sideline presenting seminars on design and art direction for Dynamic Graphics Training and *Folio:* magazine. The promotional brochures

for these events are mailed to thousands of industry professionals several times each year and, of course, there are literally thousands of people who have attended my seminars. This really gets your name out there and it's a marvelous opportunity to meet other professionals from all over the world and see the work they are doing. It really keeps you current.

Bud Willis:

We do enter selected national and international award competitions, but rarely local ones. In the past three years we have received approximately twenty-five awards, and feel that the major benefits of doing this are for its validation of our work, the promotional value for publicity, confirmation to our clients that they made a wise decision in selecting Willis Advertising, to create credibility on our Web site, and to help decorate our office walls.

Public Service Work

Liane Sebastian says that public service, or "pro bono," work is very important:

I think this is the best way to make new contacts and find new sources of paying work. Choosing carefully, doing design for a cause that you believe in gives you a lot of mileage for the time put in: you are helping the community, you are meeting new people, you have an opportunity to be daring in the design. The most successful pro bono relationships I've ever had or observed require that the pro bono clients put in some money, usually enough to cover expenses. If they don't do that, they will not respect the work they are receiving from you. I believe so strongly in this method of promotion that I make it a policy to have at least one pro bono project in-house at all times.

Leslie Burns:

Volunteering for our local design club has been great for net-working. It has also helped us to understand the needs and concerns of our clients, from their points of view. Pro bono work can help to build relationships as well, with the art director or designer that is.

Liane Sebastian underscores the potential of association activity:

Getting involved in organizations that can put you in touch with sources for pro bono work and publishing opportunities is a good way to expand your perspectives and get constructive business feedback. Overall, any promotional activity requires effort, time, work, and sometimes money. But however much energy you are willing to put in, you will get something out—rarely what you expect, but always leading to new directions.

Direct Marketing: Marketing with a Personal Touch

Whether with a stamp or e-mail, direct marketing is sending self-promotion information to your current and prospective clients. It can be the most direct and personal of all of your impersonal marketing tools.

Many designers and illustrators assume it means mailing promotion material and then making a call to see if the client received the piece. This confuses selling with direct marketing. The entire concept of direct marketing promotion is based on the design of a campaign of promotional materials with a specific objective, usually for a prospective client to contact you for more information on your services. Then, once the prospects have made a personal contact, you get to sell to them. If you send out promotions and then make a phone call, that is a sales or telemarketing campaign (see chapter 4).

PLANNING DIRECT MARKETING

Clients need to set you apart when you contact them, so design to your highest level of technical and creative and ability. Don't worry about the normally lower response rate that direct mail gets compared to selling and don't second-guess what kind of response you are going to get. Sometimes there is difference between the work you show in your direct marketing and in the work that comes from the

client's response, especially for your first assignment with them. The job the client wants you to do might not be as glamorous or exciting as the work you are showing. Just say thank you and take the job! It could just be that although a prospect doesn't have that exact type or level of work at this time, he wants to begin a relationship with you. He can do this by starting you off with whatever job he has on his desk at the moment. Don't underestimate the power of relationship-building in marketing design and illustration services.

The only guarantee you have is that if you do not do any direct marketing, you will most certainly get no response. E-mail marketing allows more flexibility in testing different approaches due to the lower production costs. Testing is always a good plan so you can determine what combination of text and images bring the most response.

DESIGN CRITERIA

Consider using a different campaign for your current clients and your prospective clients when planning your direct marketing. If all of your current clients are in the entertainment industry and your new marketing message is targeted for food industry clients, the mailings won't make a lot of sense to your current clients. Your current clients should also get more personal contact in your direct marketing than the prospective clients. Another important issue: exposing current clients to your new marketing message could lead them to think that you don't want their kind of jobs any more, and that's probably not true! With your new or updated marketing messages, you are trying to expand your business, not scare your current clients away. So if the current clients are so different from the prospective clients you want to work with, don't send current clients the new mailing; simply design a mailing just for them.

Consider also the possibility of designing different mailings for different marketing messages. Again, e-mail marketing allows the most flexibility. For example, prospective clients in a particular industry will need direct marketing text and images that they can relate to. Prospective clients that buy style are not subject or industry-

Example of crossover: Jean Tuttle's Dove Ornament Holiday Card was used as a direct mail promotion, hung in client's offices long after the holidays, and received recognition in *Print* magazine's Regional Design Annual.

specific. That could mean two different marketing campaigns. When you know a client hires designers and illustrators based on their philosophy or personal creativity, then you can send them images regardless of the industry or subject. As long as the style "message" is consistent, clients can relate and respond.

Look for crossover in your direct marketing text and images. This is any material that can be used in more than one direct marketing campaign. For example, the design or illustration for a healthcare corporate annual report can be used as a direct marketing campaign piece for a corporate communications-marketing message and a healthcare industry-marketing message. You can then get two marketing campaigns out of one piece.

THIRD-PARTY PROOF

Be sure to add credibility, or third-party proof, as often as possible to your direct marketing campaigns. Direct marketing is you saying you are a great designer or illustrator. You often need more objective evidence in your marketing to convince prospective clients to respond. A third-party proof could be in the form of client testimonials, case studies of actual jobs, or client company references. One of the best sources to use is your membership in a professional association. When clients want to hire a professional, they can look to these associations with some measure of assurance that they will find one!

Note: just to make it clear, when your marketing message is "style," credentials are less critical to response. Because of the way they buy design and illustration, clients that buy style tend to be risk-takers; therefore the issue of third-party proof is less critical.

REPETITION, RECOGNITION, RESPONSE

Repetition leads to recognition, which leads to response. This is the mantra of all direct marketing, so plan spaced repetition of your mailings. The best rule is to gear the pace of your marketing to the client's volume or turnover of jobs. For example, when you are mailing to advertising agency or editorial clients, they have a very fast

Peleg Top of TOP Design Studio features client project case studies in a direct mail campaign.

turnover of jobs and you can mail more frequently—say every four to six weeks. If you are marketing to corporations, you'll probably only need mailings every six to eight weeks, because they work at a different pace. There is a risk in mailings that are too close together: you'll lose effectiveness and annoy the prospective clients. If they're too far apart, you won't build recognition, and you will lose the equity you gained from the previous mailings.

PLAN THE WORK AND WORK THE PLAN

Once you have designed your direct marketing campaign, schedule the production, printing (for ground mail), and mailing. Remember: "The devil is in the delivery." You could have the greatest concept and design, but if the pieces don't get mailed on schedule, you cannot achieve a successful direct marketing campaign.

When you print pieces, plan ahead for reuse of the pieces you are mailing. Because the presentation of a promotional piece changes the perception of it, you can use a direct marketing promo piece again as a leave behind, mini-portfolio, or in a cost proposal. This repeat use of the investment of your time and money in direct marketing is a singular advantage of print marketing over e-mail marketing.

GETTING MORE RESPONSES

Before you design your direct marketing, decide what it is that you want your clients (or prospective clients) to do when they get the mailing. Set a specific goal: Do you want them to call for more information? Contact you for a job? Visit your Web site? Anticipate the next mailing? Ask for a special premium promo piece like a mini-portfolio or a calendar? Refer you to their associates? You must be very clear on your expectations for your direct marketing campaign. Then, be sure to let the people reading it know what their choices are in order to maximize response.

STEPHANIE DALTON COWAN
collage illustrations, paintings & photographs

visit my online portfolio at:
www.daltoncowan.com
stock art search engine with over 100 images
toll free telephone: 877.792.7096
call to request a portfolio or discuss a project
email:stephanie@daltoncowan.com

cover image: original photography & collage art created for
gift book entitled: SISTER in the Tuscany Series from Ariel Books

"artists are the myth-makers of today"
~joseph campbell

Stephanie Dalton Cowan planned to reuse her unique collage illustrations in both a direct mail postcard campaign and for her gift book, *Sister*.

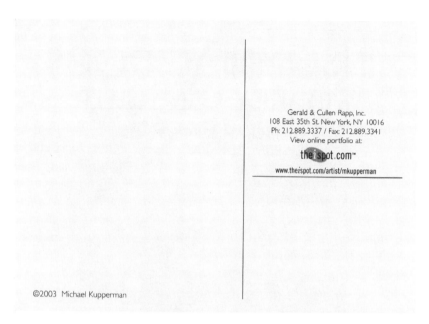

Gerald & Cullen Rapp, Inc.
108 East 35th St. New York, NY 10016
Ph: 212.889.3337 / Fax: 212.889.3341
View online portfolio at:

the ispot.com™

www.theispot.com/artist/mkupperman

©2003 Michael Kupperman

Representative Gerald Rapp, of Gerald & Cullen Rapp, uses the call to action of "View online portfolio at the ispot.com" on each illustrators direct mail, sending the client directly to the Web page desired (see this page and the following three pages).

INSOMNIAC DOGS
WHY THEY CAN'T SLEEP
BY MICHAEL KUPPERMAN

"I'M NOT WHERE I EXPECTED TO BE IN MY LIFE RIGHT NOW."

"TOO MANY BONES, NOT ENOUGH TIME."

"WHY AREN'T THERE MORE PUGS ON TELEVISION?"

"OTHER DOGS ALWAYS SEEM TO BE HAVING ALL THE FUN."

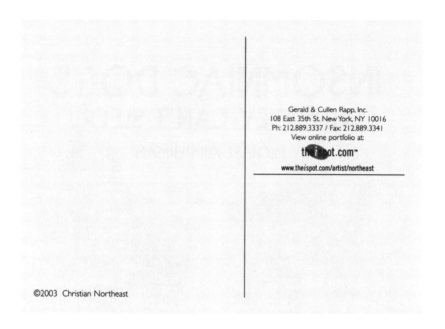

Gerald & Cullen Rapp, Inc.
108 East 35th St. New York, NY 10016
Ph: 212.889.3337 / Fax: 212.889.3341
View online portfolio at:

the i spot.com™

www.theispot.com/artist/northeast

©2003 Christian Northeast

In traditional direct marketing, you can increase the number of responses from clients by making an offer of some kind. The offer must have a greater value than the worn-out "Call for portfolio." Make an offer the client will find more valuable than the pleasure of your company. Make sure that the offer is about something they need or want. For example, you can offer a poster-size version of the image in your mailing, a book, or a calendar. This is could be your specialty advertising or premium promo piece (see chapter 5); it'll be something of value to the client that promotes your work at the same time.

THE CLIENT'S PERSPECTIVE

Remember always to write from the point of view of the client or prospective client. Successful marketing is always based on standing in the customers' shoes, and understanding their needs and interests.

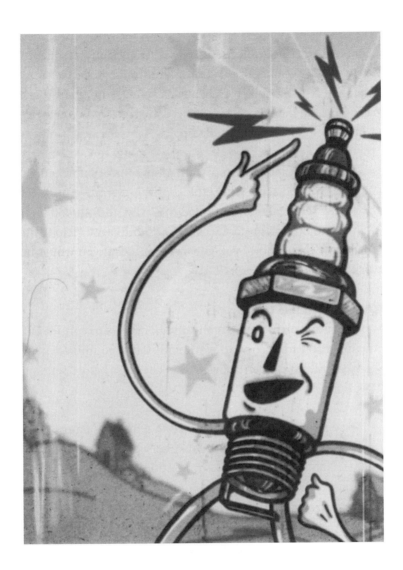

When you are including text copy in your direct marketing, be sure it mirrors the clients' wants and needs (the benefits), instead of how great you are (the features). For example, it is much more effective and meaningful to the client to write, "You need a packaging designer who can help you sell your products" than for you to write, "I am a great packaging designer."

Direct marketing response increases when your personality and philosophy as a designer or illustrator are strongly reflected. You are a total stranger to prospective clients receiving your mail—whether e-mail or ground mail. These clients need to get to know you to take the next step—response. Direct marketing by nature is a very impersonal promotion tool, so put yourself into the mailing to create a personal presence. You can add a self-portrait, biographical information, talk about hobbies, or discuss your philosophy as a creative professional. Think of this personal information as the "why" they should hire you. The "what you do" is clear to the client in your images. Help them hire you by telling them "how" you got there and what you would be like to work with.

GROUND MAIL LIST

Once you have a plan, there are the design criteria to consider. If you want your direct marketing to work and not to go immediately into the circular file (trash can), review this checklist before sending out any mailings:

- Do be sure your mail is addressed to a person's name, not just a job title. *People* buy creative services and are your true clients, not companies or job titles.
- Do have a detailed profile of your targeted client, based on your targeted marketing message, before you buy or research any mailing list.
- Do offer clear instructions of your goal for the mailing: What do you want them to do when they get your mail?
- Don't worry about your mail being tossed aside, because most mailings get pitched. Design your mailing for the people who *will* respond, not the ones who won't.
- Don't just plan a direct marketing piece; always plan an entire direct marketing campaign. Each piece supports and aligns with a coordinated, well-planned strategy.

Greg Paul designed the logo and the direct mail promos for the BIG Illustration Group for campaign consistency.

- Do make it very easy to respond: large type for phone numbers, e-mail, and Web site address. Try using fax-back response, business reply cards, and a toll-free phone number. Plan ahead to help clients ask for more information!
- Do give a deadline for response, whenever you can make this traditional technique work. It will move clients to respond immediately and keep your mailer from being placed in a pile and probably tossed or lost forever.
- Do try interactive mailings, where the client participates in some physical manner. For example, a die-cut printed

piece the client can put together. To increase response, try any design technique that requires more activity than the passive opening of an envelope or reading of a postcard.

• Do consider designing a "keeper." This is a direct marketing promotion piece you can mail that has some function or usefulness for the client (i.e., a specialty advertising piece such as a calendar or a notepad).

• Don't design a direct marketing promotion without planning a budget and timeline for the production.

E-MAIL LIST

Review this checklist before sending out any e-mails:

• Do have the "From" address accurately identify you. Hopefully, your e-mail address is your name and not some mixed up set of numbers and letters.

• Don't use a subject line of more than thirty-five characters. Use subject words that are concise and relevant to the client. The subject line should contain at least one keyword that is a benefit to the client. For example, "design for communications" or "illustration for packaging."

• Do test how your e-mail will display to clients. Broken links or raw HTML code in e-mail marketing could be problematic. Try setting up test accounts with the major online services to see how they handle your e-mail. Again, always put yourself in the prospective clients' shoes; how will this look to them?

• Don't be cute and use words like "free" or "thank you" in the "To," "From," "Subject," and even in the body (main text) of your email as these are often spam-filtered out and your e-mail will never be seen (see discussion under "Avoid spam"). Use online "content checkers" to test your e-mail for words that might trigger a spam filter. Try *www. spamcheck.sitesell.com* or *www.lyris.com/content checker*.

- Do have a good e-mail list. Your best e-mail address list comes from current clients and good prospects that have consented to e-mail contact with you. This consent may come from visiting your Web site, replying to your direct mail, viewing your portfolio, or buying a commercially available list from a reputable company. For research into buying an "opt in" e-mail list, check with your current mailing list companies and see what they have to offer. Carefully review the selection criteria they use to compile their lists.
- Do have a specific goal for your e-mail campaign. Regular contact with current and prospective clients may be two different e-mail messages. For current clients, you can be more familiar, as they already know your work. For prospective clients, you will need a reason that the client cares about. It could be new services available or current client success stories. Be irresistible!
- Do personalize your e-mail whenever possible; otherwise use the "bcc" field. It hides the other e-mail addresses you are sending the e-mail to; it's shorter, cleaner and less intrusive.
- Don't go on and on. Your very brief e-mail message should open with a couple of sentences designed to capture client's interest and active hyperlinks to selected Web pages on your site (you do not need to send them to your home page).
- Don't ignore "bounced" e-mail. "Bounced" e-mail is when you send an e-mail to an address that either no longer exists or never did. It is a good way for you to keep your own personal database clean. Also, today's ISPs have rules, from exceeding their standards for undeliverable (bounced) messages to the number of legitimate recipients you can have in one email. Break these rules and they could flag you as a spammer, blocking all your e-mail! Be sure to verify your ISP's requirements.

- Do balance text between selling messages and interesting content. Yes, include your selling message, but try adding brief "behind the scenes" content or client case-study information. This adds value to your e-mail marketing campaign and keeps clients interested in hearing from you.
- Don't think only of online response. Give clients the option to call you (toll-free numbers work very well) or to visit your Web site.

E-mail Service Providers

Should you use an E-mail Service Provider? In addition to Internet Service Providers (ISPs), there also are E-mail Service Providers. If you choose this route, you can expect the latest in privacy approaches and good relationships with ISPs. In addition, you also can benefit from e-mail filtering expertise and other elements that can help your business grow.

However, I would not advise "outsourcing" your database too much. If you plan to rely on your database as the center of your marketing communication strategy, you should stay as close as possible to it. Understanding its definitions and meanings can enable the successful marketing communications that create business success. If you or your rep plans to outsource database development and use, look for a close relationship with the database-outsourcing vendor.

Avoid Spam

Spam is one final and important thing that you should be aware of. As of this writing, there are words that you need to avoid using in your e-mails due to the use of software designed specifically to find spam (junk e-mail) and trash it. Keep in mind this subject defines the term "moving target," and the entire discipline of e-mail marketing may change with legislation pending at this time.

One of the ways that these programs currently identify spam is by the words and phrases contained in the copy (body or main text). If one of the filters catches these words or phrases, your message may

never be seen by anyone who has turned on her junk e-mail filter. Never use them in your e-mail marketing or online newsletters!

These are the current criteria used by Microsoft's Outlook and Outlook Express junk-mail filter:

- To contains friend@
- To contains public@
- To contains success@
- From is blank
- From contains sales@
- From contains "success"
- From contains success@
- From contains mail@
- From contains @public
- From contains @savvy
- From contains profits@
- From contains hello@
- Subject contains "!" *and* "$"
- Subject contains "!" *and* "free"
- Subject contains "$$"
- Subject contains "advertisement"
- Body contains "money back"
- Body contains "cards accepted"
- Body contains "removal instructions"
- Body contains "extra income"
- Body contains ",000" *and* "!!" *and* "$"
- Body contains "for free?"
- Body contains "for free!"
- Body contains "Guarantee" *and* "satisfaction" *or* "absolute"
- Body contains "more info" *and* "visit" *and* "$"
- Body contains "SPECIAL PROMOTION"
- Body contains "one-time mail"
- Body contains "$$$"
- Body contains "order today"

• Body contains "order now!"
• Body contains "money-back guarantee"
• Body contains "100% satisfied"
• Body contains "mlm"
• Body contains @mlm
• Body contains "////////////////"
• Body contains "check or money order"

Finally, the best way to check the current rules is to be sure that the list you purchase is "CAN-SPAM compliant." Check out the list of companies on the Web site, *www.targetmarketingmag.com.*

Marketing with Your Web Site

The hardest thing to predict is the future.—Yogi Berra

Most designers and illustrators have learned how to use their Web sites as advertising tools, portfolios, and even project management tools, but we are all still learning from our mistakes and our success stories. As of this writing, the following information is current, but, like I said before, keeping it updated is very much like attempting to hit a moving target. The Web site is a hybrid electronic tool—it is more like a showroom where clients can visit and be enticed to stay and "shop," or leave before a sales person gets to them. Therefore, your emphasis should be on ease of navigation and usefulness of information. The most common client negative feedback today on designers' and illustrators' Web sites is that they are "too busy, too long to load, and have annoying sound and animation effects."

SIMPLE WITH BIG IMPACT

Since your home page is the entrance to your Web site and is used by search engines to find you, it needs to work both as a portfolio and an advertisement. It should be designed to make a strong impression and get the client to request more information. Clients stopping at your home page will look for navigational information, introduction copy (who are you?), how to contact you, and evidence that other clients have found you and your site worth visiting.

Graphic design and illustration are businesses of relationships, and your Web site is often "first contact"! Help to ease the anxiety the client may feel when working with someone new. Make the site easy to use.

Strive for continuity of look and ease of navigation. You are in a worldwide marketplace with your Web site, so remember that not all your visitors are adept at the English language. For your text, the use of the first person with a conversational tone can be very effective.

Use the unique factor of the speed of electronic response time to test different offers, calls to action, and other response mechanisms. Ask for feedback and be open to learning. Since Web promotions can garner responses so much faster than print promotions, you can quickly turn around a test, get feedback, and make any changes.

Discuss technical issues with your Web site designer such as site navigation, file size, download time, and color depth and palette. As with print promotions, there can be a conflict between "make it pretty" and "make it work."

Here are some thoughts to consider when designing your Web site: Remember that your site is a promotion tool and all the basic marketing rules apply—along with all the new technology you are facing!

Lisa Cyr (*www.cyrstudio.com*) uses a lot of interesting and informative content that make her site well worth visiting (see this page and facing page).

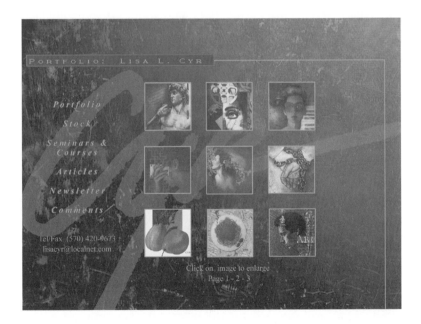

THE IMPORTANCE OF GETTING FOUND

Your site will be located mostly via search engines. Ask people how they find things on the Internet, and they'll say Google, Yahoo!, or MSN. Actually, of those three, Google is the only "true" search engine; the others are "portals" that employ other search engines such as Overture, FindWhat, and Inktomi.

These search engines use keywords and algorithms. Imagine them as "spiders" that crawl the Web and figure out if popular Web sites match the keywords that have been entered. Google became well known and well liked by adding site popularity to the process. Sites that are "hit," or accessed, more often, or that have many links pointing to them, get more priority in Google.

Still, to get a higher rating, you should pick your keywords carefully. Start with narrow, specific keywords. "Graphic design" will not perform as well as "corporate communications, graphic design." Your title tag is most important. Also, do not just list keywords into metatags. Be sure your Web designer knows how to write genuinely descriptive metatags as well written sentences that include your keywords. Finally, consider optimizing each page for the search engines. You can't direct a search just to the home page. Ideally each page should have its own set of keywords.

So, step one is to decide the keywords you will use for your metatags and search engine submissions:

- Do you have all the field descriptions required when you register your site with the available search engines?
- Fine tune the text on your Web site to become more visible. For example, find two or three key phrases for each page that relate to the material on that page.
- Use tools such as *www.wordtracker.com* to research the most common search phrases and words. Some search engines use your metatag keywords; some use your home page text to search. Study carefully before you decide what text you will supply. This will determine how high up you

rate in a typical search. You want to make it into the top
ten "matches," so decide on your keyword list in the design
and before you register your site with the available search
engines. This should work whether your client types in
your name or a more general description such as "corpo-
rate communications graphic designers and illustrators."
- Remember, it takes up to two months for a search engine
to index a Web site once you have submitted. And submis-
sions expire, so submit them semiannually.
- Don't overlook the free online lists. These are mostly avail-
able from your industry directory sites, online discussion
groups, and design and illustration industry associations.

Step two is to look for people and firms with which to exchange
links to bring you up to the top of any search for your services. This
is the "popularity" factor—meaning the number of Web pages with
links back to your Web site—mentioned earlier.

And finally, step three: Previously, your clients would search on a
keyword and the most relevant matches would come up first. Today,
you may pay for position or even inclusion in the search results.
Overture, FindWhat, Sprinks, Inktomi, and even Google now offer
paid results placements. These payment methods fall into two cate-
gories: "Paid Placement" and "Paid Inclusion."

Paid Placement

"Paid Placement" calls up a link to your site every time a searcher
types in a keyword you've selected. You pay each time the keyword is
picked. This can be expensive, particularly with the larger search
engines such as Google. If this appeals to you, you might want to try
a smaller search engine to keep your costs down.

Paid Inclusion

"Paid Inclusion" might be seen as the "White Pages" compared to paid
placement's "Yellow Pages." Paid inclusion does not change the

ranking or placement of content. Rather, it just offers a direct link to someone looking for your special product or service. While pay-based strategies can be valuable, these tactics won't replace solid keyword and content management.

GETTING YOUR SITE TO ACT FAST

By using a home page with content that loads quickly, you can capture clients' attention and then invite them where to go next. Even though more of us now have high-speed Internet access, if your site is "hit" frequently enough, the site itself can run slowly if laden with demanding features. With thumbnail photos, or even just a text description, the prospective client can then click immediately on an area of interest without leaving your site. There are many other ways to make the site load fast, but generally, try to avoid animations and sound effects, tempting as these might be.

The best sites avoid making visitors go through extensive scrolling down to reach their next destination. Remember, you are designing self-promotion for a monitor screen, not a printed page. The simpler the better when it comes to the Web site, so the copy should be simple and explain what portfolios are available for viewing. Your goal is to get the clients to "pick and click" on a specific area of interest from the home page and they need to be able to make that decision quickly or you will lose them. Portfolio categories are very useful for clients to identify your marketing message (and their interest in you).

Use simple backgrounds that do not interfere with the text. Design with easy-to-read fonts that are not so elaborate or animated that they interfere with reading the text. Try for contrast between the background color and the text so that it is easy to read, but can still print out as legible copy. An interesting note: if your text is written in a color too similar to the background, the search algorithms ("spiders") are actually trained to identify this as spam, resulting in an exclusion from the search engine.

Be specific and use categories such as advertising design, editorial illustration, corporate communications, exhibit graphics, packaging

illustration, and Web design. Also, be sure to include content you can change on a regular basis, such as a current client projects or association event information. Be sure clients can print out the screen page of information they will want to keep (such as your contact page or directions to your studio) without the text falling off the printed page.

Finally, and most importantly, as suggested in Drew Haygeman's excellent observations at the end of this chapter, make sure that your ultimate Web page design resonates with and reinforces your overall target marketing message. Your Web presence should work with you, not against you, in further establishing your unique brand identity via your target marketing message. Be irresistible!

CLIENTS LOVE CHOICES

Clients are people and people love choices. It is important to give clients options but keep them on your site as long as possible. Perhaps you could present a thumbnail overview of images in each category. The client can then click on a button called "View More Images" to see a more complete portfolio. Paging back and forth between thumbnails and full images keeps them on your site longer, and builds cumulative interest in your work. Also, be sure your contact information is on each page. Try including a "Contact us for more information" button on each page that allows the client to e-mail you without leaving your site.

Add links on each page that send clients to places on your site rather than have them back up or click until they get bored and leave!

CONTENT IS KING

Find ways to add interesting content to your site. "The search engines will reward you for being informative," says Stephen Gorgey, president of Target Logics of Glendale, California. When you add "editorial" to your promotion copy, you give clients the potential to hit your site during their research and another reason to revisit your site. Identify pro bono work you are doing, industry-meeting announcements, interesting trade news items, upcoming industry conferences,

a discussion thread, a survey, or a contest. Be careful to make this consistent with your target marketing message, though. Obtain links from other Web sites that relate to your marketing message. Use any technique to create interest and interaction. This requires a lot of maintenance but will build reputation, recognition, and loyalty to your site.

Are Blogs For You?

Some e-marketing writers feel that if you want to get traffic to your site quickly in today's Internet environment, you have to learn how to blog effectively. A blog is a form of monologue.

> A blog is a Web page made up of usually short, frequently updated posts that are arranged chronologically—like a "what's new" page or a journal. The content and purposes of blogs varies greatly—from links and commentary about other Web sites, to news about a company/person/idea, to diaries, photos, poetry, mini-essays, project updates, even fiction. —From *www.blogger.com*

Blogs have been very popular, but recently there has been some "blog fatigue." Some get understandably weary of tuning into one person's personal musings over and over again. To blog successfully, it seems that you have to be endlessly fascinating. If you are ready to maintain that level of personal interaction, you can add this to your site to stimulate more frequent visits from clients.

Content is a great strategy, but be aware that it won't produce immediate results. It will take time for the Google "spiders" to find your site, and more time for your site's popularity to build with an increased number of hits.

THE CALL TO ACTION

Response-based promotions contain a call to action. While your Web site will serve many purposes, this is one of them. What is the call to action that you will use? How will that action be imple-

mented? It is important to give clients options such as an e-mail response, a toll-free number to call, or even a fax number to request more information.

IT'S STILL ABOUT RELATIONSHIPS

A downside to e-commerce is that text cannot convey emotion effectively. You are dealing in a cold, impersonal medium so try to warm things up with visual messages that are not overly complex. Strive to establish a dialogue with your clients. Respond to their requests quickly and always plan for follow-up. Be personal and personable. Decide with them when will you next be in contact with them. You are in charge of follow-up.

Obviously, be sure to add your URL to everything printed including business cards, letterhead, envelopes, mailing labels, logo labels, note cards, photo print labels, slide captions, estimates, invoices, in every outgoing e-mail (use the signature block), and all promo pieces, mailers, and ads. Be careful with signature blocks, as they can be perceived as impersonal. Customize your signature block with personal comments or references and update it on a regular basis.

Write both print and electronic press releases to submit to the appropriate media announcing new services available on your Web site. Update your own site often and be sure to keep the "Last updated" or copyright date current.

Finally, find a Web hosting service that will offer design and maintenance tools to allow you to get exactly the site you want.

BRINGING IN THE DATA

You should think about ways to harvest new data in the form of e-mail addresses from visitors. Perhaps "opt in" newsletters or project releases page. Clients can also register with you to receive more information (such as a mini portfolio) or to pass along a referral for your services. Note chapter 3's references to "registration forms."

Even more important, be sure you are gathering statistics on your site and examine patterns in your site-visitor behavior. What were

they searching for when they found your site? What keywords did the clients use? What common terms did clients use most often when searching for specific types of design and illustration? And, of course, which thumbnails were opened most often? This tells you directly which of your images were most eye-catching.

We then cycle right back to the beginning: getting found. With your data harvest, you can much more effectively decide the keywords you will use for your metatag page and search engine submissions.

Tim Cohn, marketing strategy consultant and president of Advanced Marketing Consultants, Inc., put it extraordinarily well in his feature on building Web traffic in *Target Marketing Magazine* (*www.targetmarketingmag.com*):

> Not considering keyword and keyphrase demand prior to constructing a Web site is akin to building your dream home in a run-down neighborhood—both turn a large investment into one with little market value.
>
> I, too, like many Web site owners, experienced the reduction of my initial Web site investment to one with little or no value. After a year and a half of substantial financial and emotional investment, I angrily concluded that my site-development costs had produced little or no returns.

Tim recommends the Overture inventory tool to learn the terms most people use when searching; find it at *www.overture.com*. Tim also recommends that you "enter terms that best describe your business until you find matching phrases. Produce a list of possible terms, and then re-evaluate how your site can be 'repackaged' to fit the more popular terms."

Tim calls this "Demand Alignment." On his own Web site, *www.marketingprinciples.com*, the words he selected to use in his title bar result in a number-one listing spot among four major search engines and directories (Google, Yahoo, MSN, and AOL), when you search for the term "marketing strategy consultant."

SPECIAL TIPS FOR ILLUSTRATORS

Lisa L. Cyr, of Cyr Studio (*www.cyrstudio.com*), offers this special advice for illustrators:

> For illustrators, it's important to have both a presence within a group site as well as an individual site—one that is more customized to what they uniquely offer the marketplace. The group sites, which offer variety and selection, attract buyers and are a way for an artist to increase online traffic. Once a buyer is interested in a particular artist, a link to an individual site can provide further information and a more extensive body of work. The combination of the two is key. Our Web site, *www.cyrstudio.com*, has been a very effective marketing tool for my partner and me. Because of the unique combination of work that we do, we needed a site that would be flexible enough to showcase our illustration work as well as my writing, lectures, and workshops. The site provides a portfolio and stock catalog, a listing of articles and books, a series of workshops and classes, and an online newsletter called The Creative Edge. In the newsletter, I discuss current topics, post my industry articles and links, and other interesting things for illustrators. Our site is simple and easy to use and the content is readily accessible right from the home page. Updates can be made easily and instantaneously—offering a fresh view for buyers who frequent the site.

SPECIAL TIPS FOR GRAPHIC DESIGNERS

Tony Colombini, design principal for Corner (*www.cornerusa.com*), describes how multiple modes of entry can be leveraged into a more effective Web presence:

> For clients who have never heard of us we are listed at several listing sites. In fact, our biggest billing client one year found us at *www.yellowpages.com*. Another place for new clients to learn about Corner is on "portfolio" sites. We get about five leads a month with a listing on Verisign, and a dozen or so from Brandera. We use our

own Web site as a go-to place for the new leads to pre-qualify our clients and we post comps for our existing clients on our site for them to approve.

Tony loves the quantifiable dimension of Web presence and its ability to use valued content to keep visitors coming back:

> The real key to the Web is that it is measurable. We can tell with Web-Trends how each page performs. We can "instantly" change and alter a page to make it most effective. We have studied this with our site at *www.cornerusa.com* this year. Our clients and prospects have turned to our site to get business tips and studio updates. We have a monthly e-Newsletterette, the Corner Post, that directs prospects and clients to the news page on our site. Our Case Studies share vital information on the effectiveness of our designs. The process page shows our clients that the creativity they are buying is built on sound practice and determination, not on whim. We have added a FUNZONE to share the capabilities of our free-lance associate Kahlen Freeman, which is entertaining and branding our firm with a sense of humor. We are looking at launching a dramatically new Web site in 2004. This new launch will give us fodder for more PR and promote all of our strengths. Lately we have used our Web server as a place to post progress comps for our clients in other regions to approve. This has created a great value for our clients.

Notice how Tony emphasized providing content-based value in his client relationships. Even in the e-commerce world, relationships matter, and content value makes the difference.

Drew Haygeman, President and CEO of Graphic Design Firm HIJK/printQuick, reinforces this point. The biggest shift in Web presence is toward quality and away from just the number of hits:

> Thinking back to the not-too-distant past, the popular opinion regarding how to best utilize a Web site was that having a site was

all about attracting viewers. And so, often, what viewers did when they got to a particular site was secondary. Attracting viewers to your site still remains a primary necessity. But, just as importantly, what is the mutual benefit of that visit? Today, savvy Web marketers have a growing appreciation of the value of the Internet toward creating and managing relationships. Ultimately, I believe this to be the real value of a Web site. So the answer to the question is, first, list your site where the "quality" of the viewers is more important than just the "quantity." Ask yourself; will the kind of viewers I'm attracting to my Web site help me accomplish my goals? If so, sure, it makes sense to list with like-minded portals or portfolio listings. If not, a clear understanding of your particular market will dictate where your Web site will be most effective.

The challenge of Web site design today is making your site distinctive among literally millions of possible sites. Drew notes that traditional analytical frameworks are making a strong comeback in this rapidly changing area. Note Drew's concentration on marketing identity and branding by following a consistent look between Web and print media; this exemplifies the effective use of your target marketing message:

> For online success, look offline. To deal with this question I like to eliminate as much "hype" as possible by thinking of a billboard as opposed to the Internet. As the number of Web sites increases exponentially, the similarities between the two media are more numerous than we may like to admit.
>
> For one thing, all visual media, whether static or dynamic, are competing for our time and attention. The basic principles of visual communication apply across the board. It is untrue, for instance, that somehow because the word Internet is attached to the method of communication we need not pay attention to simplicity and clarity of intent. In fact, the opportunities for miscommunication are compounded by interactivity, as are the opportunities for positive results.

Dig deep into what your target market is really trying to learn about your company, your product, and your service from your Web site. Take a close look at how that market is best informed. And don't forget what you want back. Web communication is powerful simply because your target audience is defining its interest at the most significant time in their decision-making process, when they are thinking of you not necessarily when you are thinking of them. At this critical juncture they can make an important decision about their course of action relating to your company. Should they register? Should they purchase? Should they print something? Should they book a meeting? All are positive outcomes. Create an avenue for gathering the data based upon actions. The Web is truly powerful and underutilized for targeted, mutually beneficial communications.

We've all seen Web sites that are technically sound but have very little relationship to the brand culture of a company, as promoted in all its other noninteractive communication tools. An easy path toward effective Web sites is to look offline for online success.

Writing Your Marketing Plan

For your personal marketing strategy, always begin with your "marketing message" (what you are selling). It is the verbal statement of the visual work you are marketing. Since it identifies the design or illustration work you want, it also identifies the targeted client. Given the great number of designers and illustrators to choose from, this message and positioning in the marketplace will help the client remember to contact you and not your competition! It must be consistent throughout all your print and electronic promotions.

REFLECTIONS FROM A CLIENT

Think, too, about the clients' point of view—their perspective in looking at your marketing. Jessica Hoffman, senior art producer for Crispin Porter & Bogusky, believes in the value of ad placement. "Ads you place, or, better yet, a credit of any ads being celebrated in any awards book or trade pub, are widely read and trusted by most creatives. Look out for all of those 'call for entries' and submit! Source books such as *Workbook*, *Alternative Pick*, and *Blackbook* are still very much relied upon. Pick the one that suits you best. Show more than one image."

Jessica also thinks highly of Web sites, but offers a word of caution. "Do make Web sites easy to maneuver through—this sounds picky, but time is a commodity. Huge honking watermarks over every

image simply annoy me. Find another way to alert me to your copyright terms. No long loading times—I like being able to click on an image and see it larger size. Show either more or less images than what's represented in your portfolio, not the same exact stuff."

Despite the new world of e-commerce, Jessica still puts a lot of faith in direct mail:

> For some reason, having a physical reminder of your work works better for me. Maybe my memory could be improved upon, or it could be my brain hasn't yet completely evolved into this new method of working electronically—filing all those bookmarks for the Web sites I've marked. Printed pieces are excellent tangible reminders and work well in a spur of the moment meeting—something in hand to throw up on a wall for consideration. Mail every three months or so. Make sure your name is on the outside of the piece and include your Web address. Reasonably sized pieces, original in content, and well executed equals a keeper. Multiple images are better than one—folded accordion style or a few cards in a clear envelope works well for me [and] don't send posters.

In closing, Jessica reinforces a "tried and true" element of any creative professional's promotion strategy: the portfolio. "Portfolios, wonderful portfolios. They remind us of the art within this wonderful craft. We all get to slow down for a minute and study. Take pride and care in creating one. I have to be able to present something that speaks not only for the style and capabilities of the photographer, but their professionalism or originality as well."

USE ALL THE TOOLS

Remember, marketing is the overall goal and it breaks down into the four tools: advertising (which includes Web sites), direct mail (which includes e-mail marketing), public relations, and personal selling. You need a plan of action for each tool.

Marketing Tools

I have included two outlines for a typical marketing plan. Neither is specifically your marketing plan, but each is designed to show you how to proceed from here. Now that you have read the book, it is time to put your new knowledge to work. I recommend the outline format because it is much easier to read and review, add to and update throughout the year, and it is less work to write.

The key to successful marketing is to "plan the work and work the plan." There are two important features to the success of your plan. One is that you break down every action into small pieces or tasks. Second is that you take these bite-size tasks and cross-reference them to your daily planner. You have perhaps heard this before (chapter 8)—have you done it yet? If you have done it, maybe you now need to use the calendar cross-reference. Ultimately, the only way to integrate the creative and marketing tasks is to use one calendar for both. The same calendar you will use to manage projects is the one you use to schedule all of these marketing tasks.

The idea of planning and scheduling may sound inflexible and rigid, but the net effect is quite the opposite. Without needing to worry about marketing, you now have the attention and energy to be

more creative. With all your self-promotion tasks already on your calendar, you are now free to create. You are free to put all your time, attention, and energy into your design and illustration work—where it should be.

SAMPLE MARKETING PLAN FOR DESIGN

FRAMEWORK:
I. Consistent Marketing Message
II. Who We Are Selling to
III. How to Get the Work

PLAN:
I. Consistent Marketing Message
 A. Corporate Communication Promotions and Annual Reports
 i. To create design projects and meet the needs of corporate clients to communicate and influence their various publics.
 ii. Design projects can also be a solution to a problem the corporation perceives as a marketing issue.

 B. Action Step
 i. Schedule meeting with partners to develop six benefits of working with our design firm for corporate communications solutions instead of with our competition.

II. Who We Are Selling to
 A. Companies with in-house corporate communication directors that use outside design firms
 i. For better projects, they should be in the top twenty-five of each of the industries we are targeting.
 ii. Industries we can target include hotel/travel/resort, financial services, environmental services, healthcare services, entertainment, sports, telecommunications firms, and business services.

B. Action Steps
 i. Schedule several days of research to identify databases of corporations with communications directors.
 ii. Then, check on the top companies in each category. Research and subscribe to the trade publications in above industries.

III. How to Get the Work
 A. Direct Mail Campaign
 i. Need to create concept, design, and schedule production of campaign:
 a. Mailed every eight weeks.
 b. Should be a self-mailer with response card.
 c. Needs to make a strong offer to increase response
 d. Use crossover copy to appeal to all corporate communications directors.
 e. Objective of our mailing is to "cull" any bought lists with responses to create our own personal database of potential clients.
 f. The design should also work double-duty as a "mini-portfolio" for clients to get and keep on file.
 ii. Need to research mailing lists that match above profile.
 iii. Action Steps:
 a. Call "Labels To Go."
 b. Contact National Register for Standard Directory of Advertisers database.
 c. Check availability of specific corporations by industry.
 d. Schedule concept meeting with partners to layout the design of mailer.

 B. Advertising Campaign
 i. Develop concept for industry association ad, based on overall objective of getting response from corporate communications:

a. Objective is to impress with marketing message and ask for response to add to personal database for sales calls.

b. Focus on corporate communications problems and solutions with image selection/copy.

ii. Update Web site every month with new content, and double check that URL is printed on all promotions, ads, mailers, invoices, e-mail, everything!

iii. Action Steps:

a. Call corporate communications associations and get their media kits to check display ad rates and deadlines.

b. Schedule Web site updates.

C. Public Relations Campaign

i. Should reach both clients as well as other design professionals (for referrals).

ii. Plan quarterly project press releases to all media, including local community.

iii. Start entering any and all design awards programs with both self-assignment and published work.

iv. Submit project success stories press releases to client and design industry publications for possible feature articles.

v. Identify potential public service projects in which to become involved.

vi. Action Steps:

a. Build database of all media and editors of design industry publications, client publications, and community publications, and all awards programs.

b. Check deadlines.

c. Schedule press releases every quarter.

d. Review existing work and upcoming projects for award entry and possible feature article submissions.

e. Check with Chamber of Commerce for local charities that need pro bono work.

D. Personal Selling (Client Relations)
 i. Concentrate quality time on the best bets—clients for assignments—and plan schedule of calls for follow-up with:
 a. Past clients of any kind for their corporate communications work.
 b. Past prospects for corporate communications work.
 c. Responses from direct mail, ads, and Web site.
 d. Leads from referrals.
 e. Leads from mailing that are considered best-bet clients.
 ii. Keep personal sales list small and manageable:
 a. By making ten calls a week and having a personal database of approximately one hundred people, client contact will be an eight to ten week cycle.
 iii. Action Steps:
 a. Design personal database for sales calls and follow-up calls.
 b. Schedule sales calls and follow-up calls on calendar.

E. Portfolio
 i. Continue to use the CD and inkjet prints of work, but downsize to 8" × 10" as the outside size for the mat board for the prints.
 ii. Create a multi-industry body of work, rather than a specific portfolio, as the overview portfolio, so the follow-up to bring back more specific work is built in.
 iii. Action Steps:
 a. Buy new portfolio cases for travel.
 b. Create three duplicates of corporate communications portfolio for traveling portfolios.
 c. Schedule quarterly review of portfolio to reformat and to upgrade as new work comes in.

F. Promo materials
 i. Continue with black folder with cover logo label.

 ii. Use publicity reprints or inkjet copies of images for consistent appearance, along with existing bio and capabilities information printed on letterhead.

 iii. This is now our capabilities brochure, sent upon request for more information about our firm, and also used as a leave-behind after a portfolio presentation.

 iv. Plan on series of inkjet color copies of pages from new corporate communications projects as visual promo pieces.

 v. Review multiple uses of direct mail pieces designed for re-use as a mini-portfolio.

 vi. Action Steps:

 a. Build inventory of all promo pieces and reorganize existing promo materials.

Very similarly, you have the same tools to use for the planning of marketing illustration services. Note that the following plan, while well organized, is not written in the strict outline style of the first one. Both are viable; it's up to you to write the plan in a form that is most useful to you.

SAMPLE MARKETING PLAN FOR ILLUSTRATION

FRAMEWORK:

I. What We Are Selling

II. Who We Are Selling to

III. How To Get the Work

PLAN:

I. What We Are Selling

This is our marketing message (the work we want to do more of), and it must be consistent throughout all promotions, including concepts for portfolios, direct mail ads, and promotion pieces.

MARKETING MESSAGE: "Advertising Illustration." My job is to create illustrations for ad campaigns to meet the needs of ad agencies and their clients in the following industry areas most interesting to me: travel, healthcare, and financial services.

ACTION: develop benefits of working with me based on my style of illustration being most suitable for these ad campaigns

II. Who We Are Selling to
Ad agencies and their clients: travel, healthcare, and financial services. For broader reach in my marketing, I will also look to design firms and publications in these areas.

ACTION: schedule several days of research to identify databases of ad agencies, design firms, and publications. Research and subscribe to the trade publications in above industries.

III. How To Get the Work
A. Direct Mail Campaign
i. Need to create concept, design, and schedule production of three different campaigns:
a. Mailed every eight weeks.
b. Should be a self-mailer with response card.
c. Needs to make a strong offer to increase response.
d. Use images and copy that illustrates the benefit of my illustration style.
e. Objective of our mailing is to cull any bought lists with responses to create our own personal database of potential clients.
f. The design should also work double-duty as a mini-portfolio for clients to get and keep on file.
ii. Need to research mailing lists that match above client profile.

ACTION: check *www.workbook.com*, *www.adweek.com*, *www.adbase.com*, and *www.freshlists.com* for mailing lists.

ACTION: schedule concept meeting with partners to layout the design of mailer.

B. Advertising Campaign
 i. Develop concept for Web site, online ad, and sourcebook ad based on overall objective of getting response from prospective clients:
 a. Objective is to impress with marketing message and ask for response to add to personal database for sales calls.
 b. Focus on specific marketing message advertising campaign concepts for image selection and copy.
 ii. Update Web site every month with new content, and double check that URL is printed on all promotions, ads, mailers, invoices, e-mail, everything!

ACTION: call sourcebooks and get their media kits to check display ad rates and deadlines. Schedule Web site updates.

C. Public Relations Campaign
 i. Should reach clients, as well as other and illustrators, to build word-of-mouth name recognition (for referrals).
 ii. Plan quarterly project press releases to all media, including local community.
 iii. Start entering any and all illustration awards programs with both self-assignment and published work.
 iv. Submit project success stories as press releases to all three media publications for possible feature articles.

ACTION: build database of all media and editors of industry publications, client publications, and community publications, and all awards programs. Check deadlines.

Schedule press releases every quarter. Review existing work and upcoming projects for award entry and possible feature article submissions.

D. Personal Selling (Client Relations)
 i. Concentrate quality time on the best-bet clients for assignments, and plan schedule of calls for follow-up with:
 a. Past clients of any kind for their advertising illustration needs.
 b. Past prospects for same.
 c. Responses from direct mail, ads, and web site.
 d. Leads from referrals.
 e. Leads from mailing that are considered best-bet clients.
 f. Keep sales list small and manageable. By making twenty calls a week and having a personal database of less than two hundred, client contact will be an eight to ten week cycle.

ACTION: design personal database of above names for sales calls and follow-up calls. Schedule sales calls and follow-up calls on calendar
 ii. Portfolio.
 a. Continue with portfolio CD and a print mini-portfolio for each of the industry areas being targeted. Create a multi-industry body of work on the web site as the overview portfolio.

ACTION: schedule quarterly review of portfolio to reformat and to upgrade with self-assignments and new work as it comes in.
 iii. Promo materials.
 a. Get a new folder that has the die cut for business card and a CD, use cover logo label. Use publicity reprints or inkjet copies of images for consistent appearance, along with existing bio and capabilities information printed

on letterhead. This capabilities brochure can be sent upon request for more information about your firm, and also used as a leave-behind after a portfolio presentation. Review multiple uses of direct mail pieces to be cut apart to reuse as a mini-portfolio. Design for a series of project information pieces with images and text as additional promotion pieces.

ACTION: build inventory of all promo pieces and re-organize existing promo materials.

Books from Allworth Press

Allworth Press is an imprint of Allworth Communications, Inc. Selected titles are listed below.

AIGA Professional Business Practices in Graphic Design
edited by Tad Crawford (paperback, 6¾ × 10, 320 pages, $24.95)

Creating the Perfect Design Brief: How to Manage Design for Strategic Advantage
by Peter L. Phillips (paperback, 6 × 9, 208 pages, $29.95)

Business and Legal Forms for Graphic Designers, Third Edition
by Tad Crawford and Eva Doman Bruck (paperback, 8½ × 11, 208 pages, includes CD-ROM, $29.95)

Business and Legal Forms for Illustrators, Third Edition
By Tad Crawford (paperback, 8½ × 11, 160 pages, includes CD-ROM, $29.95)

The Education of an Illustrator
edited by Steven Heller and Marshall Arisman (paperback, 6¾ × 9⅞, 288 pages, $19.95)

Starting Your Career as a Freelance Illustrator or Graphic Designer, Revised Edition
by Michael Fleishman (paperback, 6 × 9, 272 pages, $19.95)

The Graphic Designer's Guide to Clients: How to Make Clients Happy and Do Great Work
by Ellen Shapiro (paperback, 6 × 9, 256 pages, $19.95)

The Graphic Designer's Guide to Pricing, Estimating, and Budgeting, Revised Edition
by Theo Stephan Williams (paperback, 6¾ × 9⅞, 208 pages, $19.95)

How to Grow as a Graphic Designer
by Catharine Fishel (paperback, 6 × 9, 256 pages, $19.95)

The Education of a Design Entrepreneur
edited by Steven Heller (paperback, 6¾ × 9⅞, 288 pages, $21.95)